Coloring Books for Adults

Good Vibes for Relaxation

Copyright © 2019 Violet Miranda

ISBN: 9781693352829

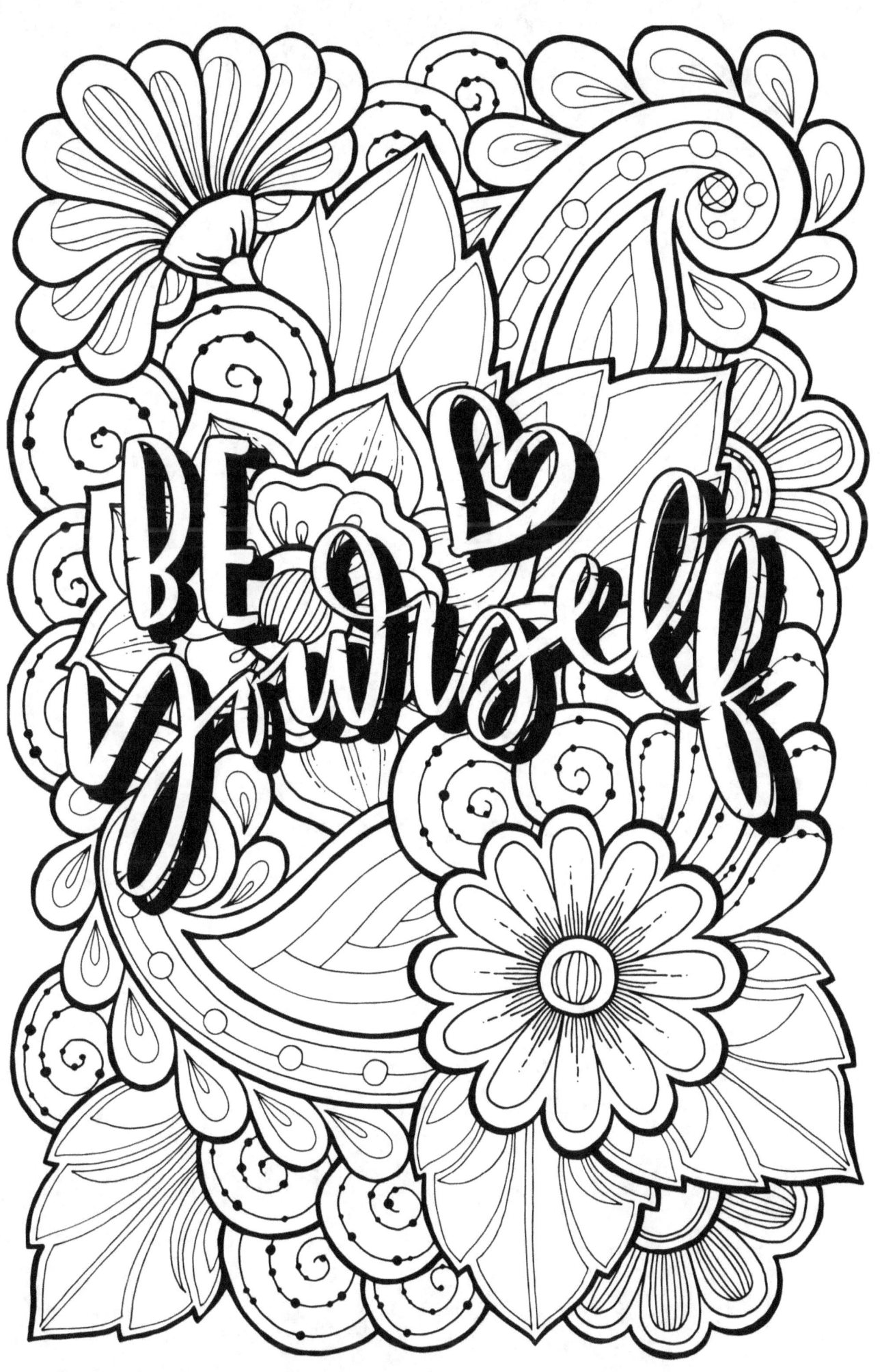

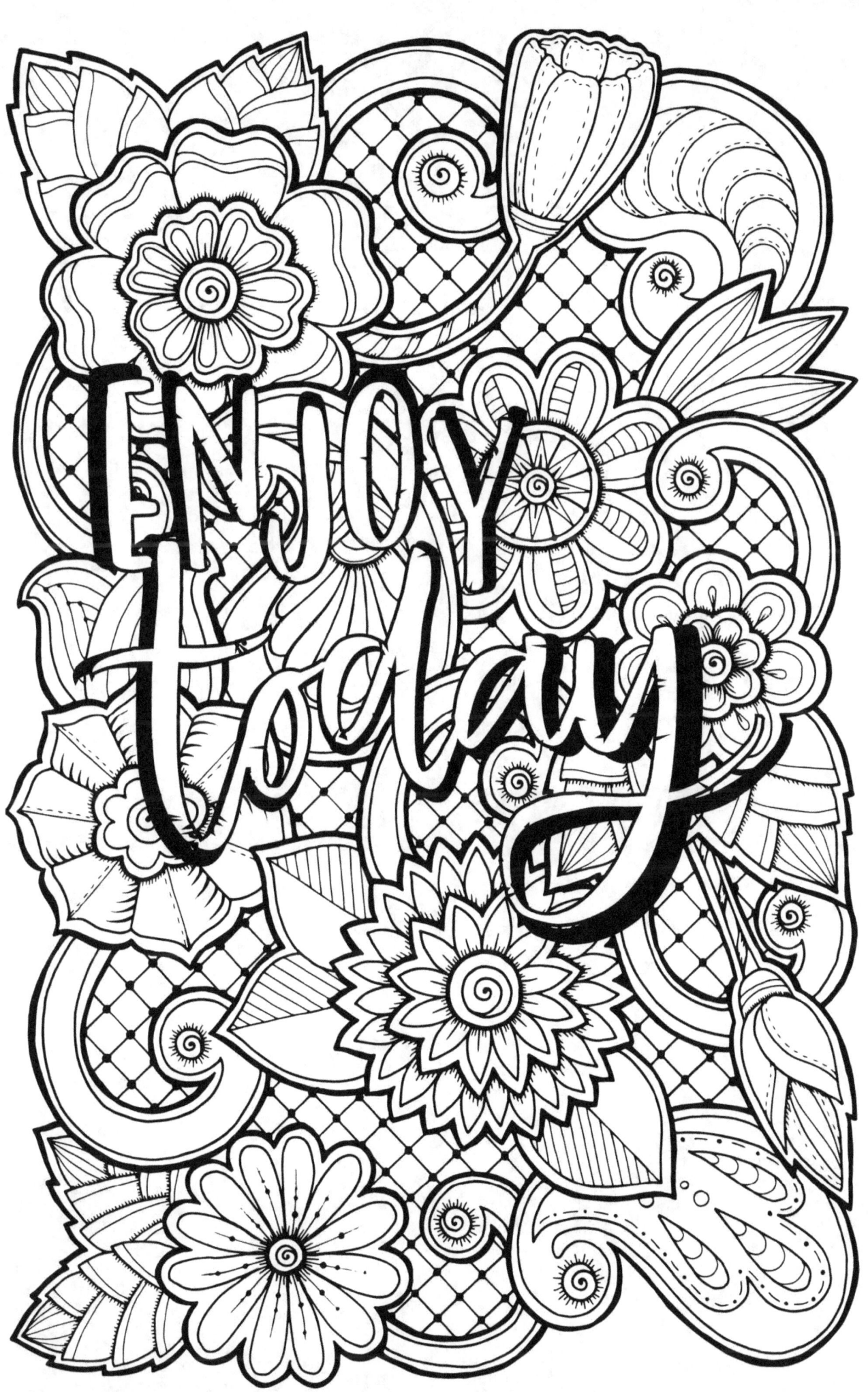

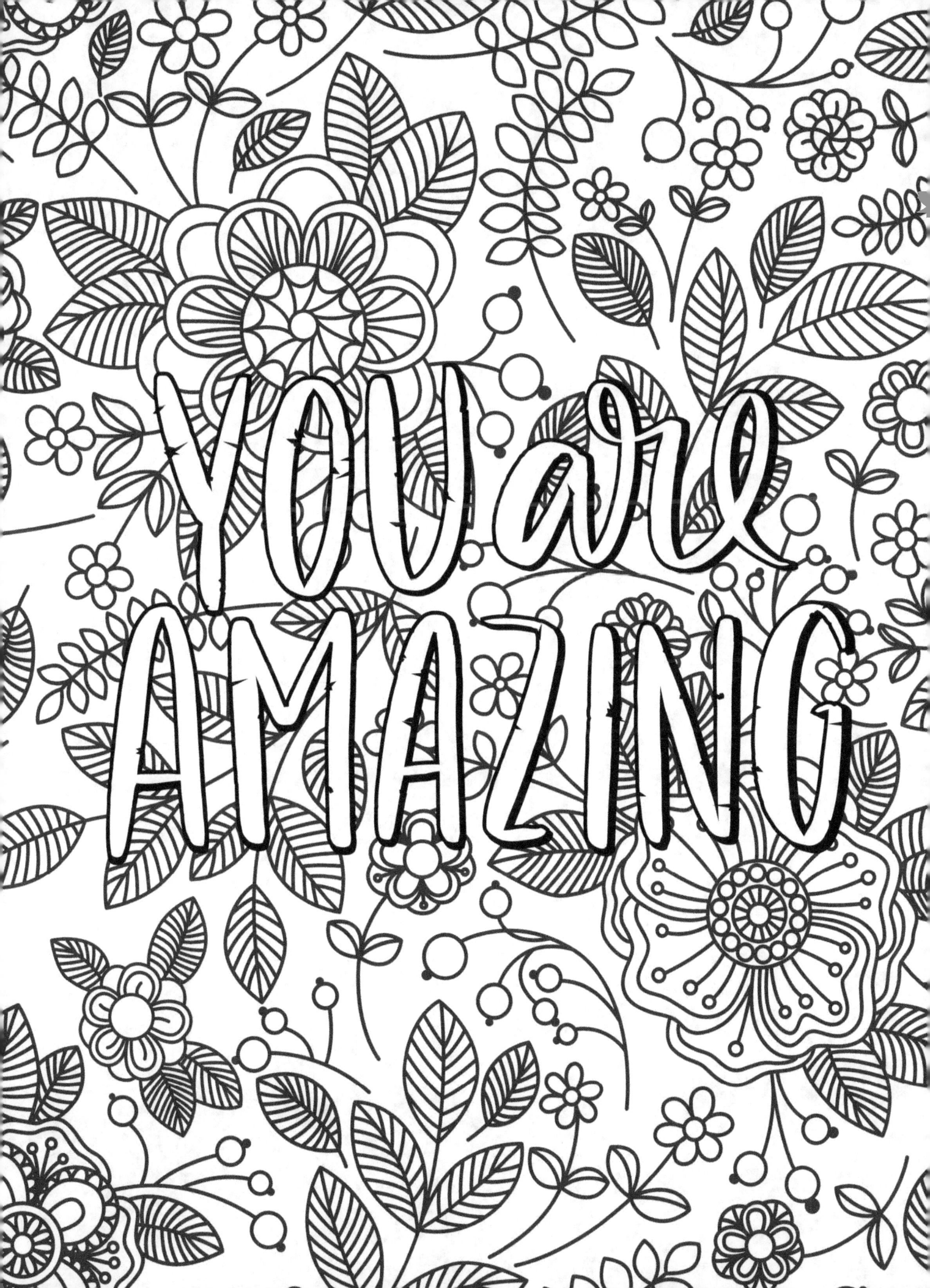

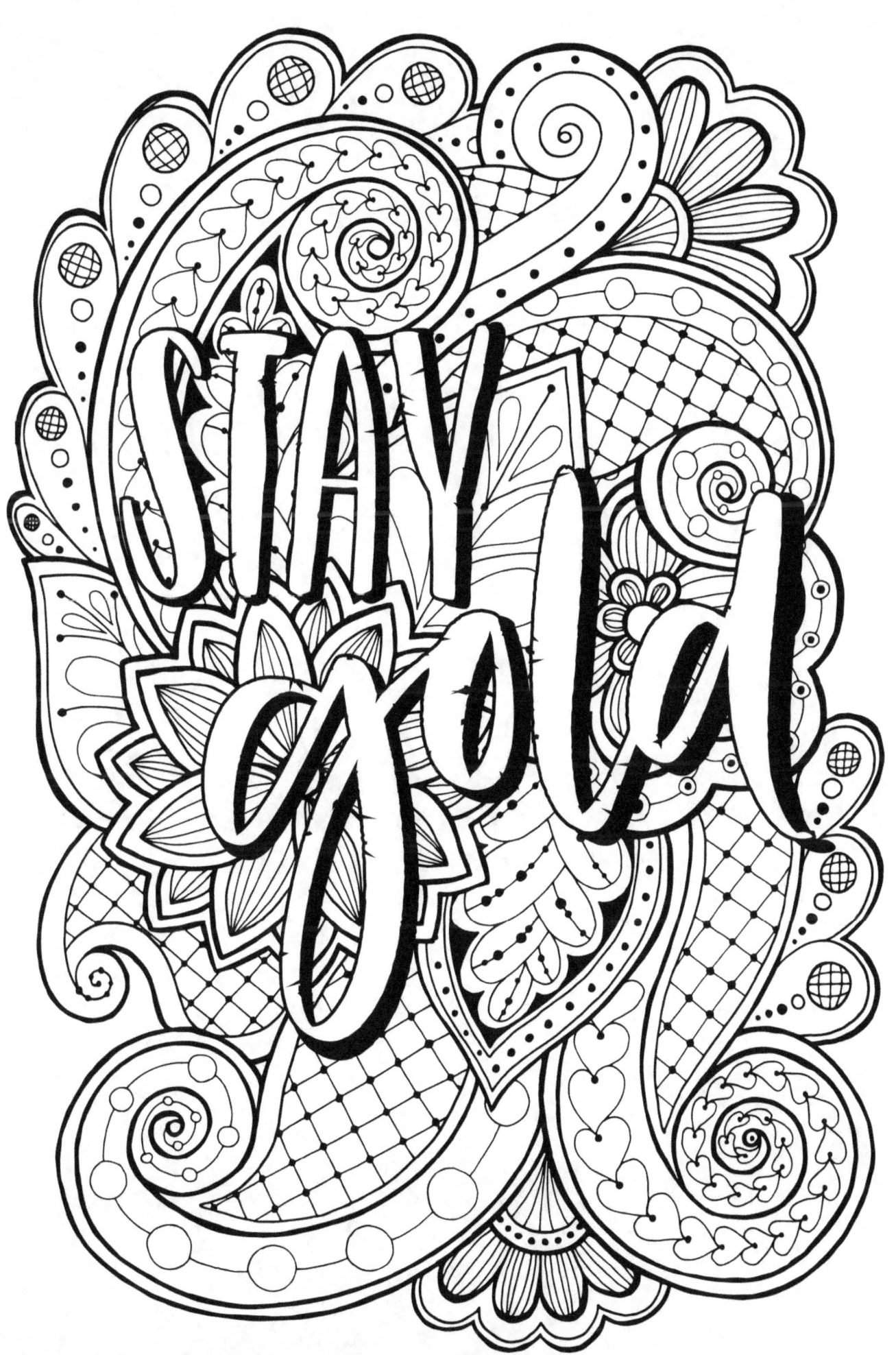

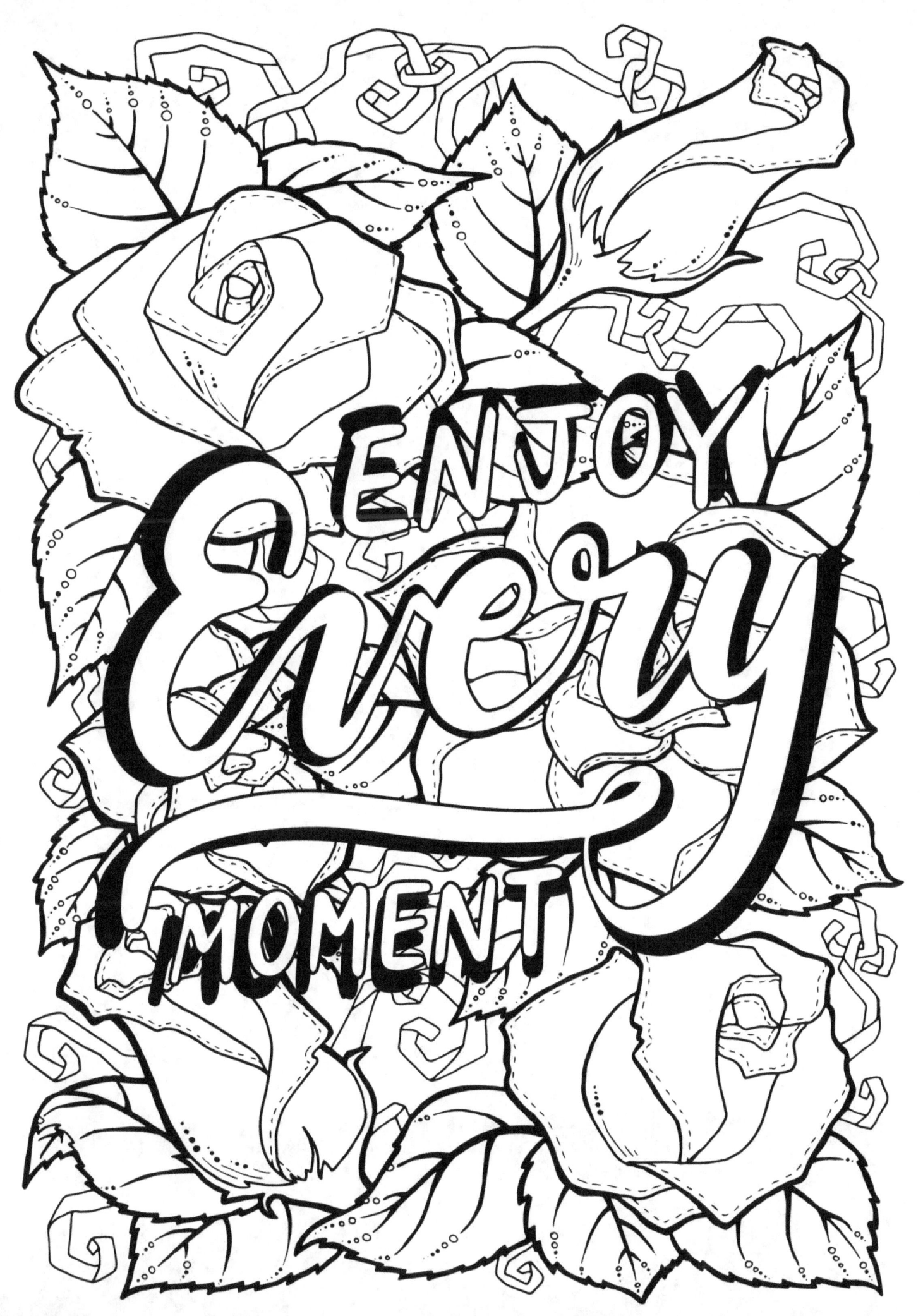

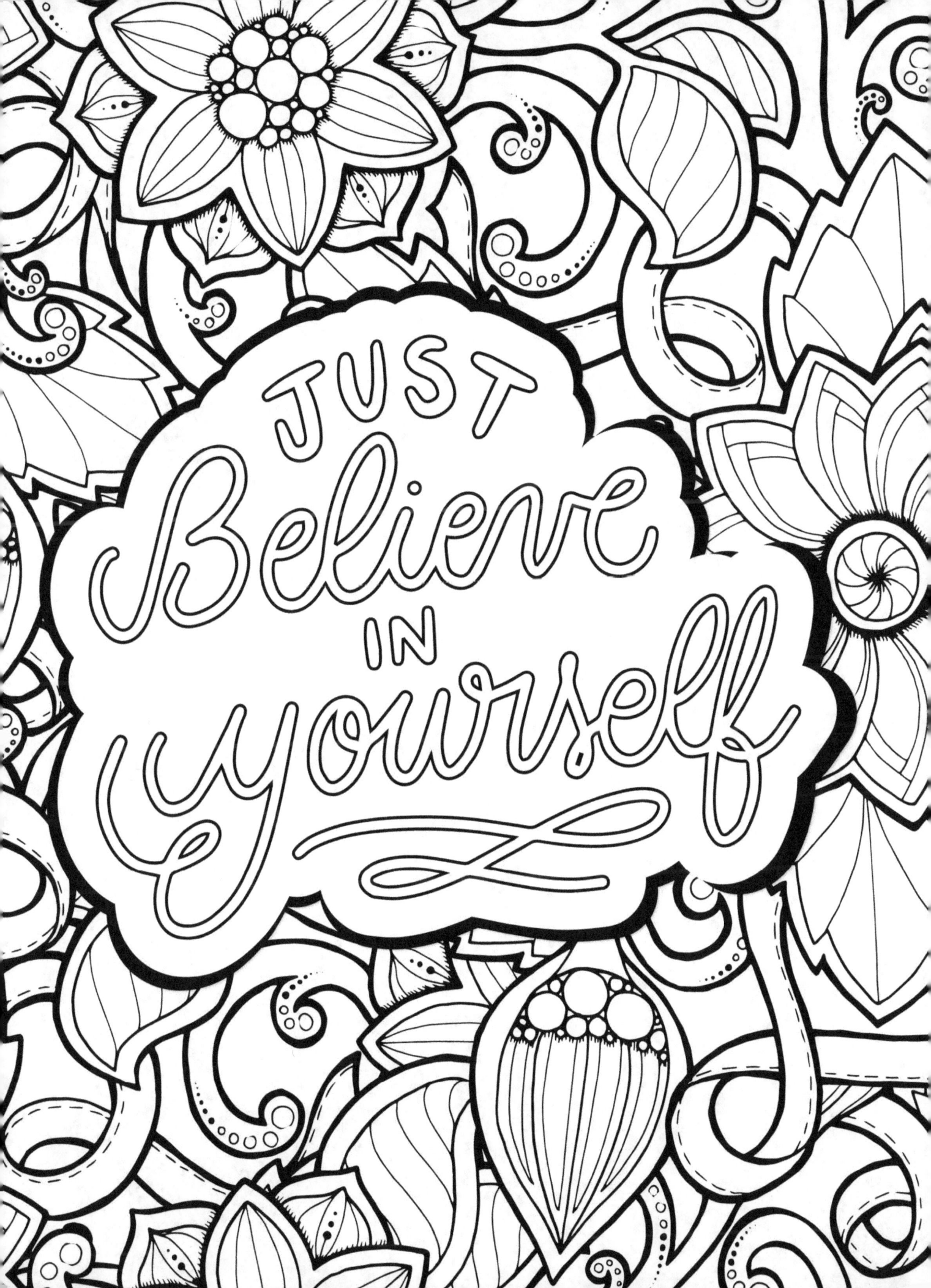

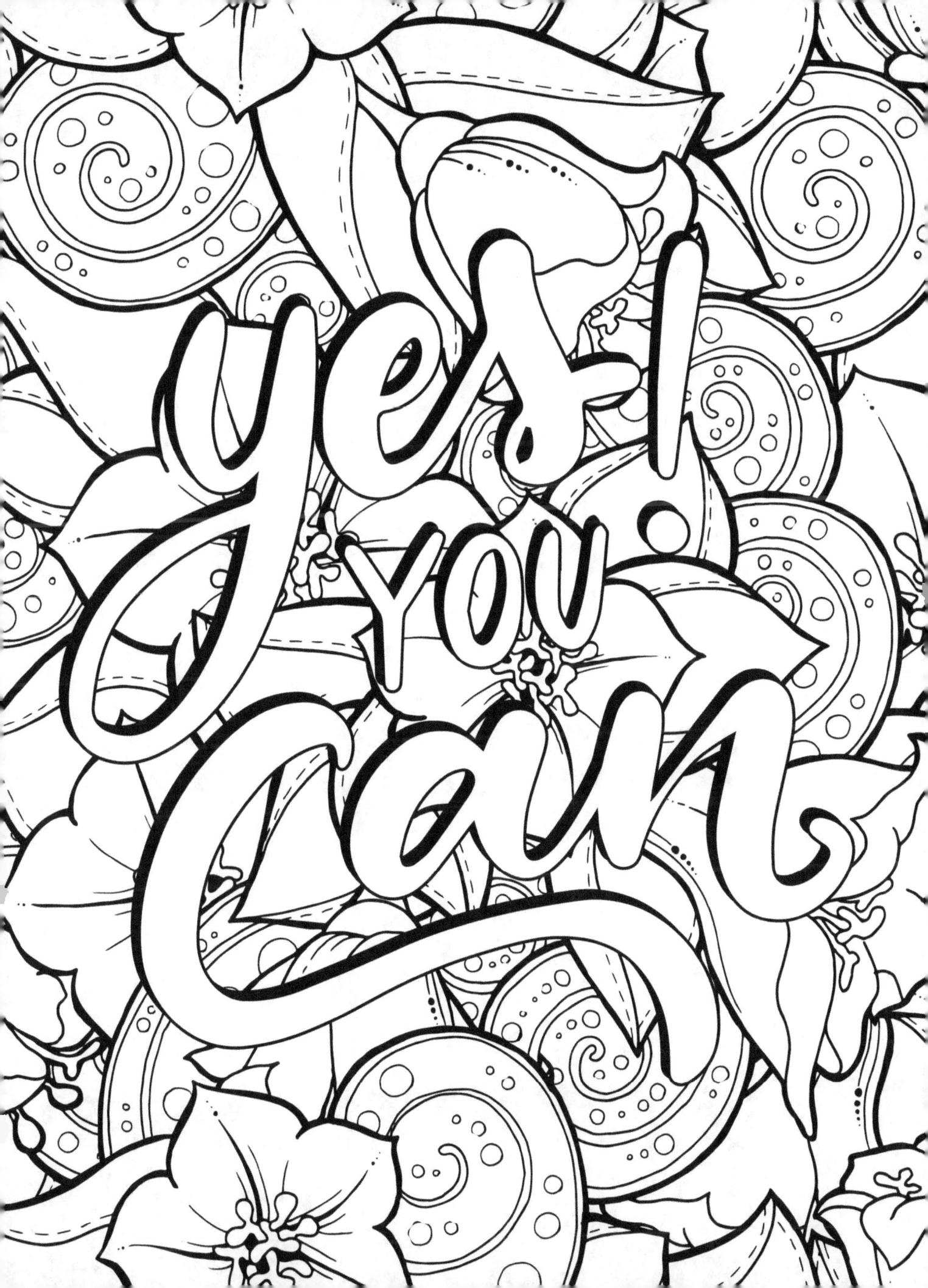

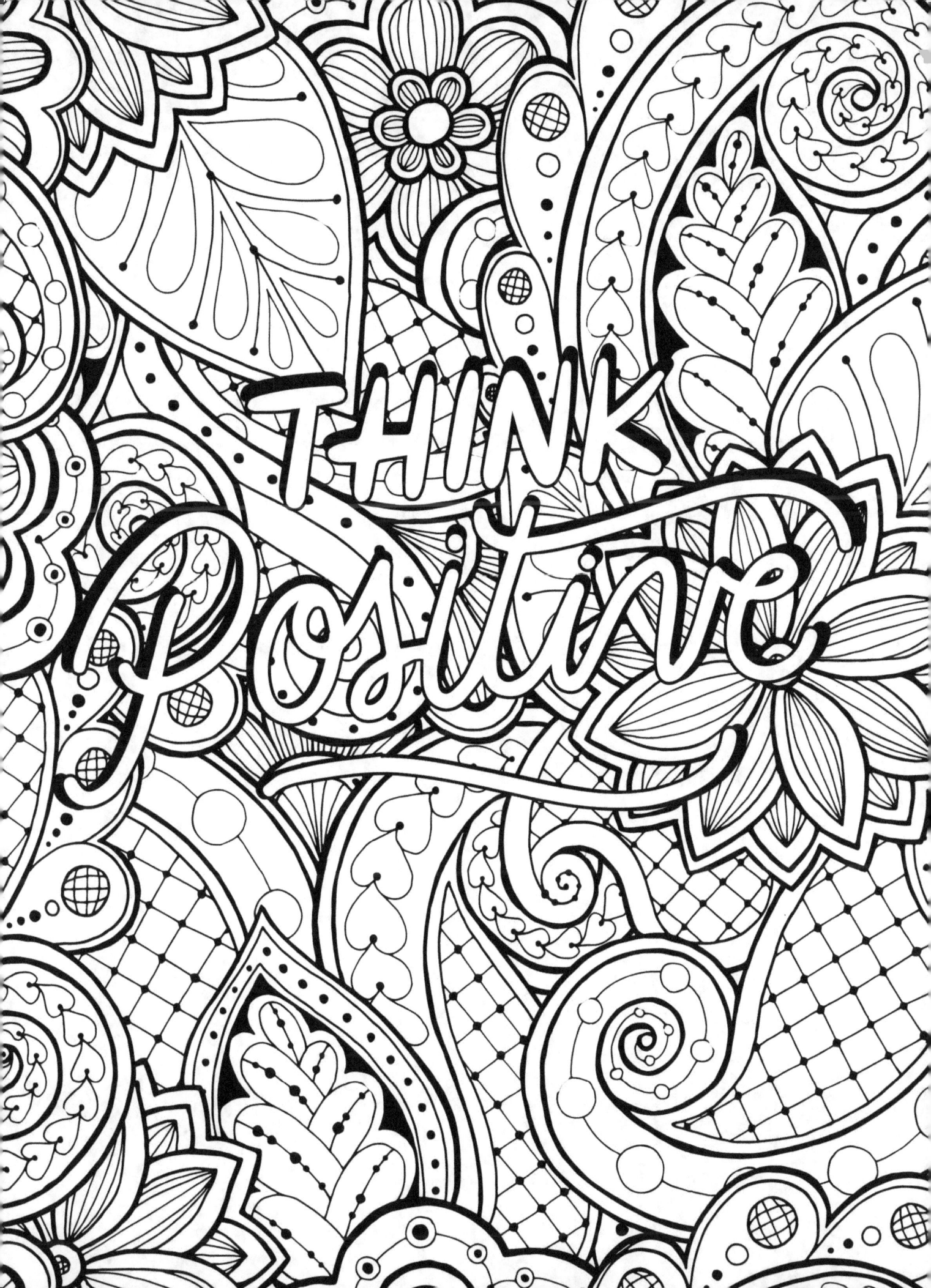

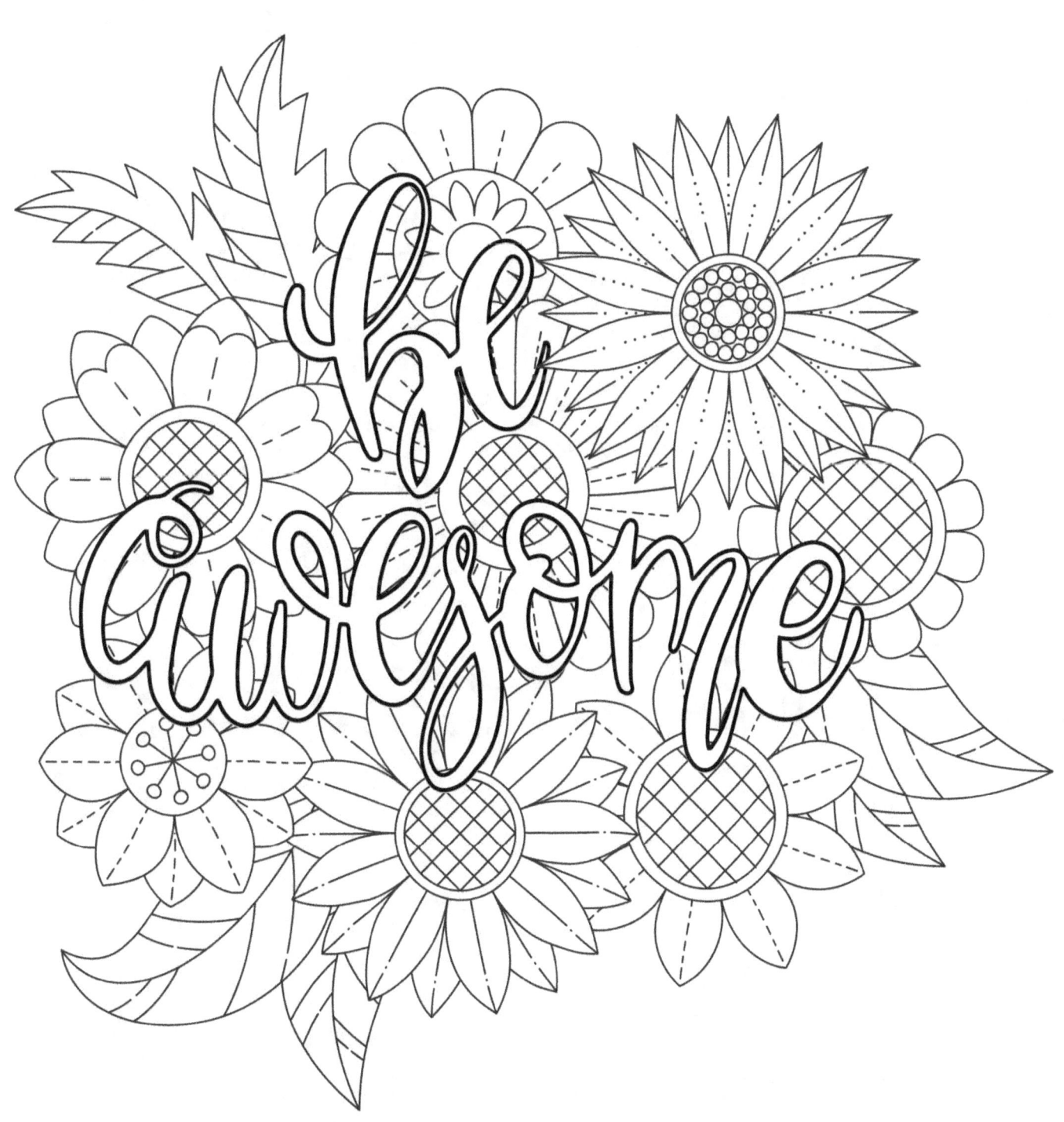

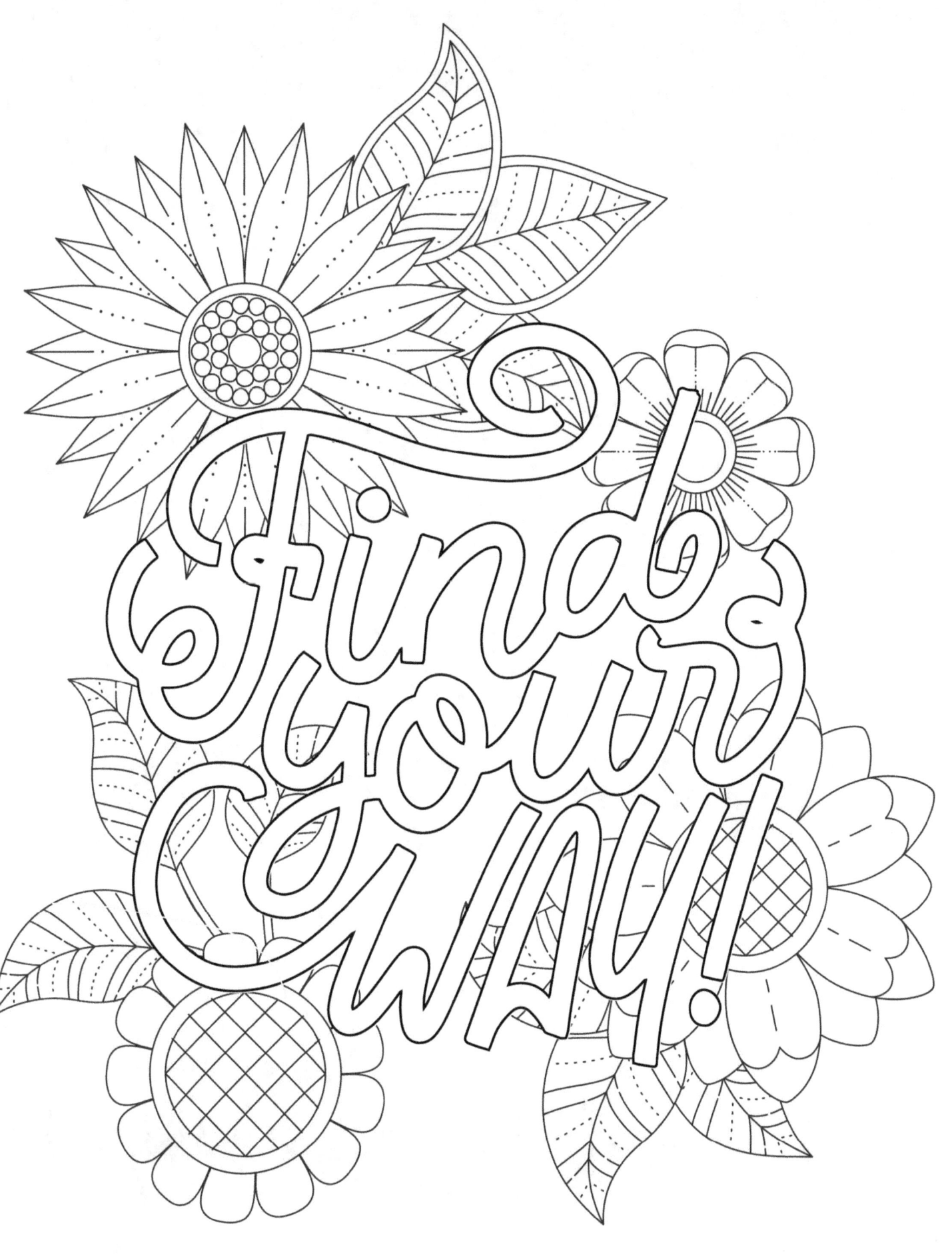

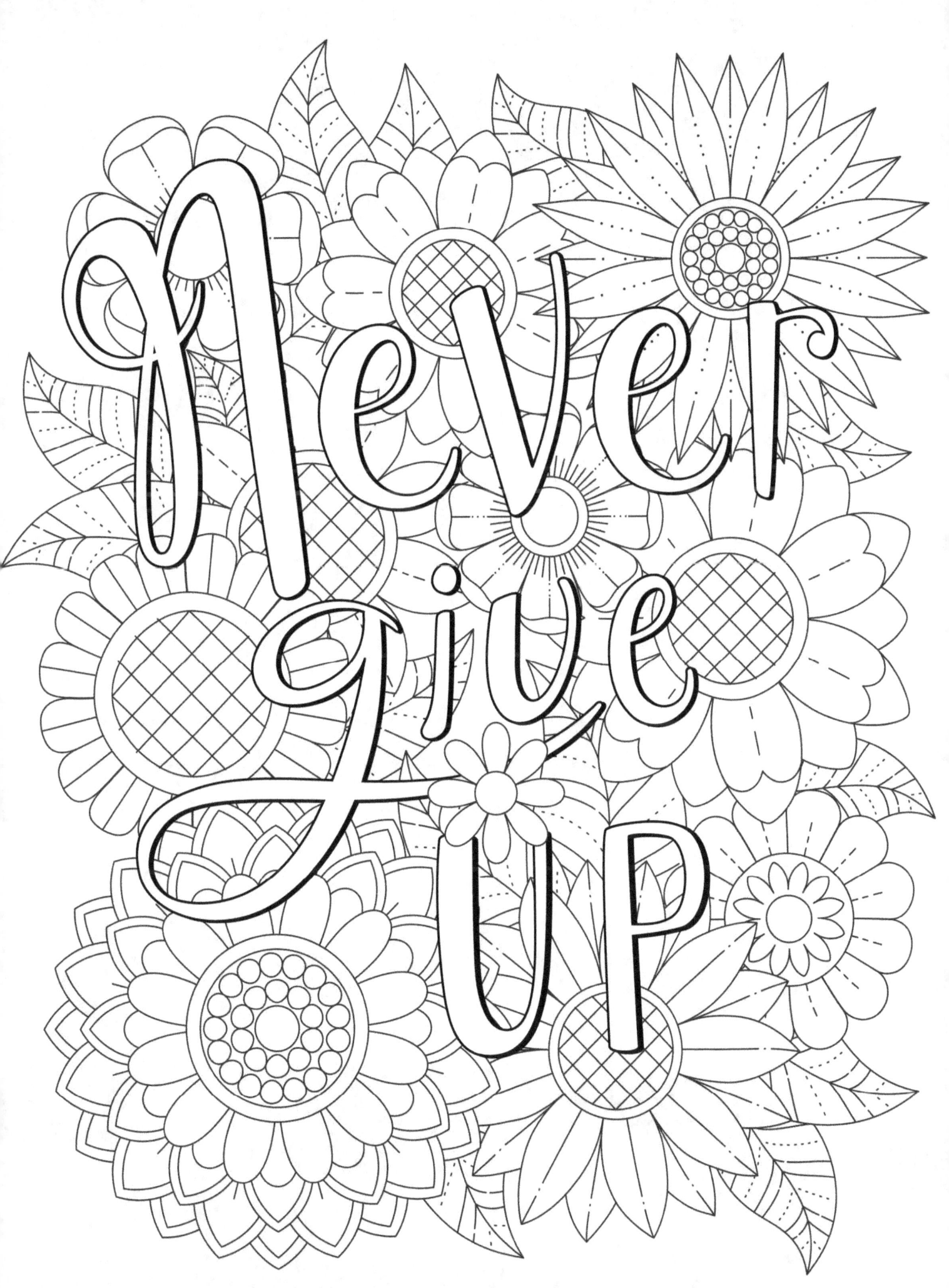

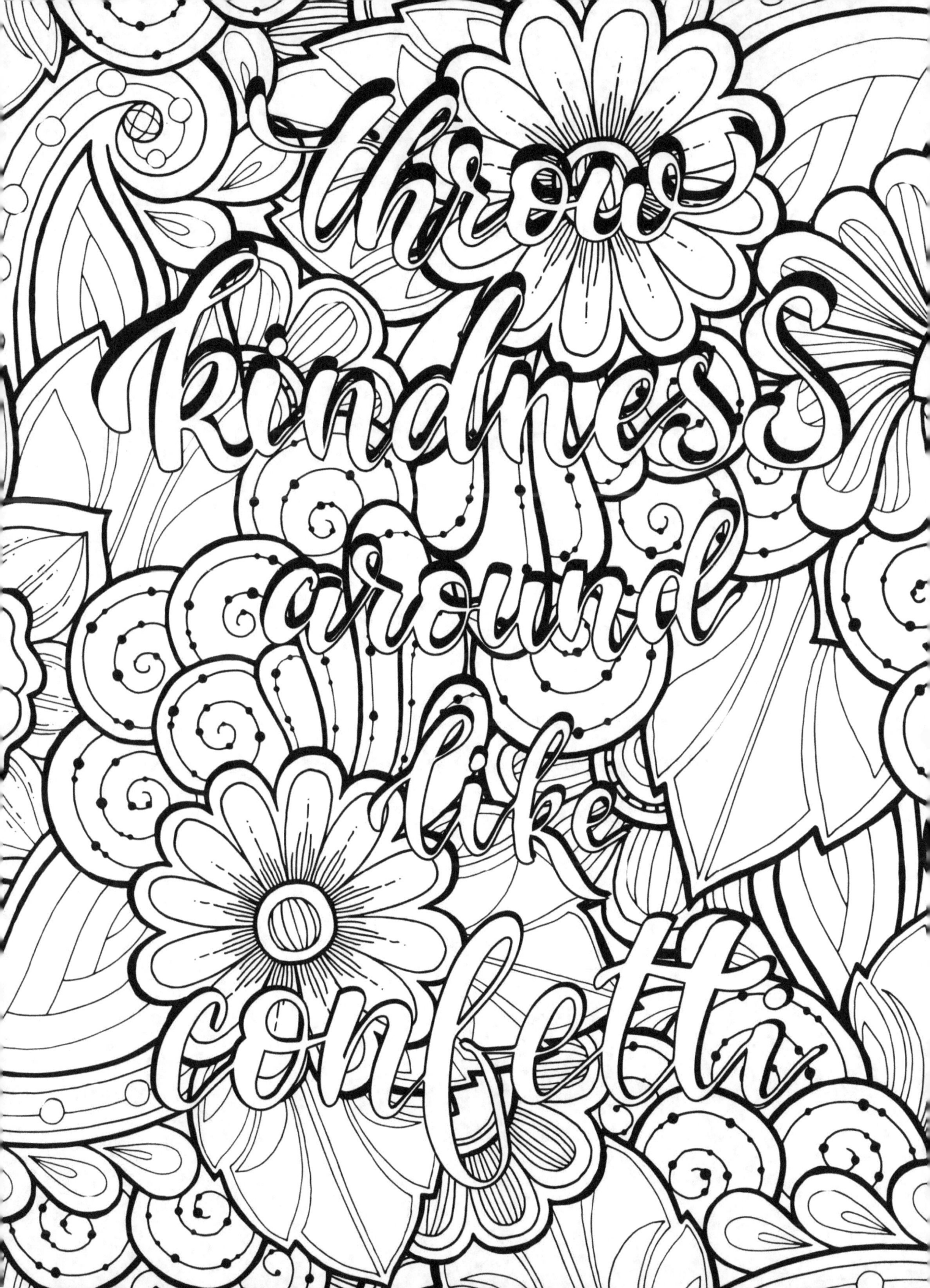

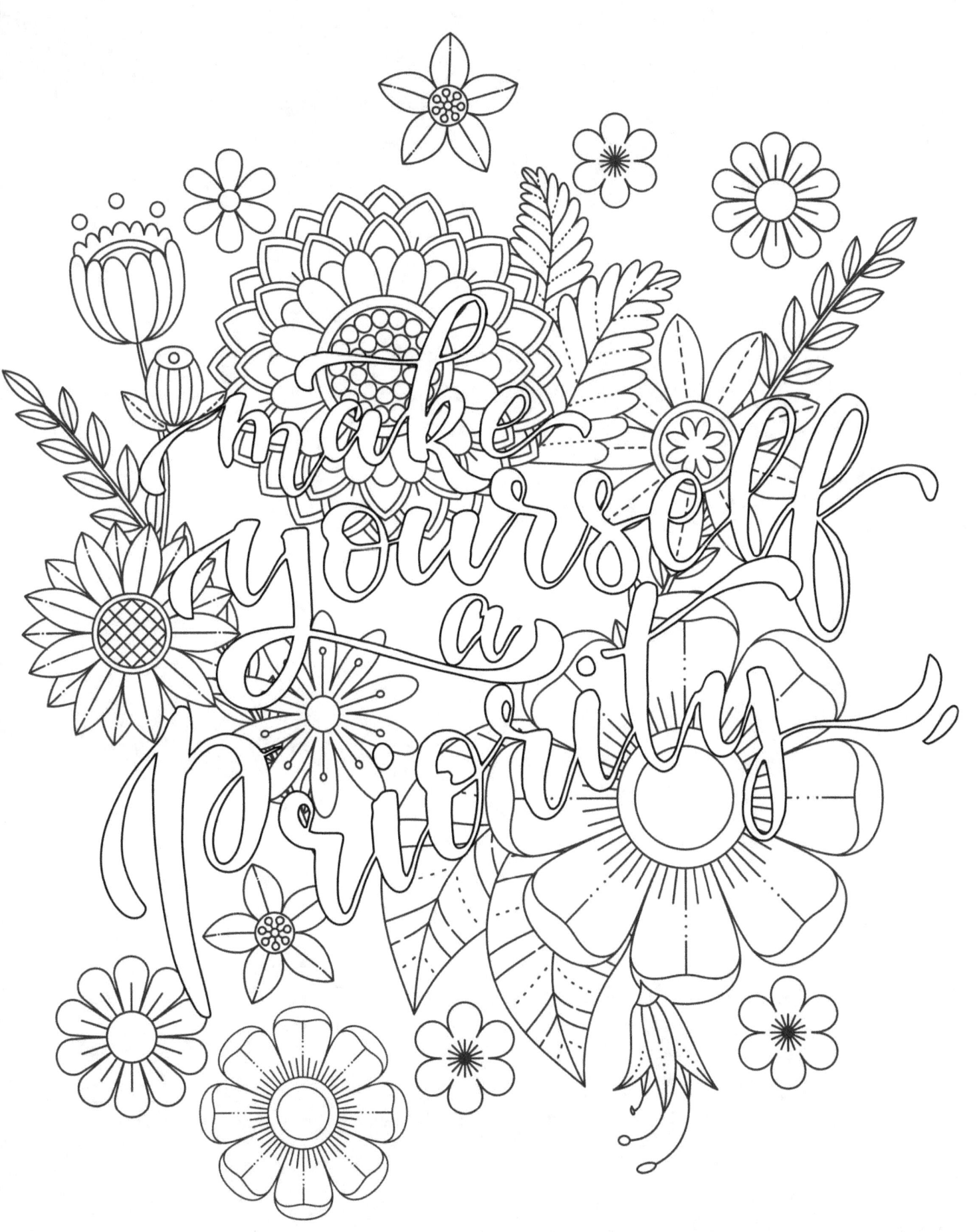

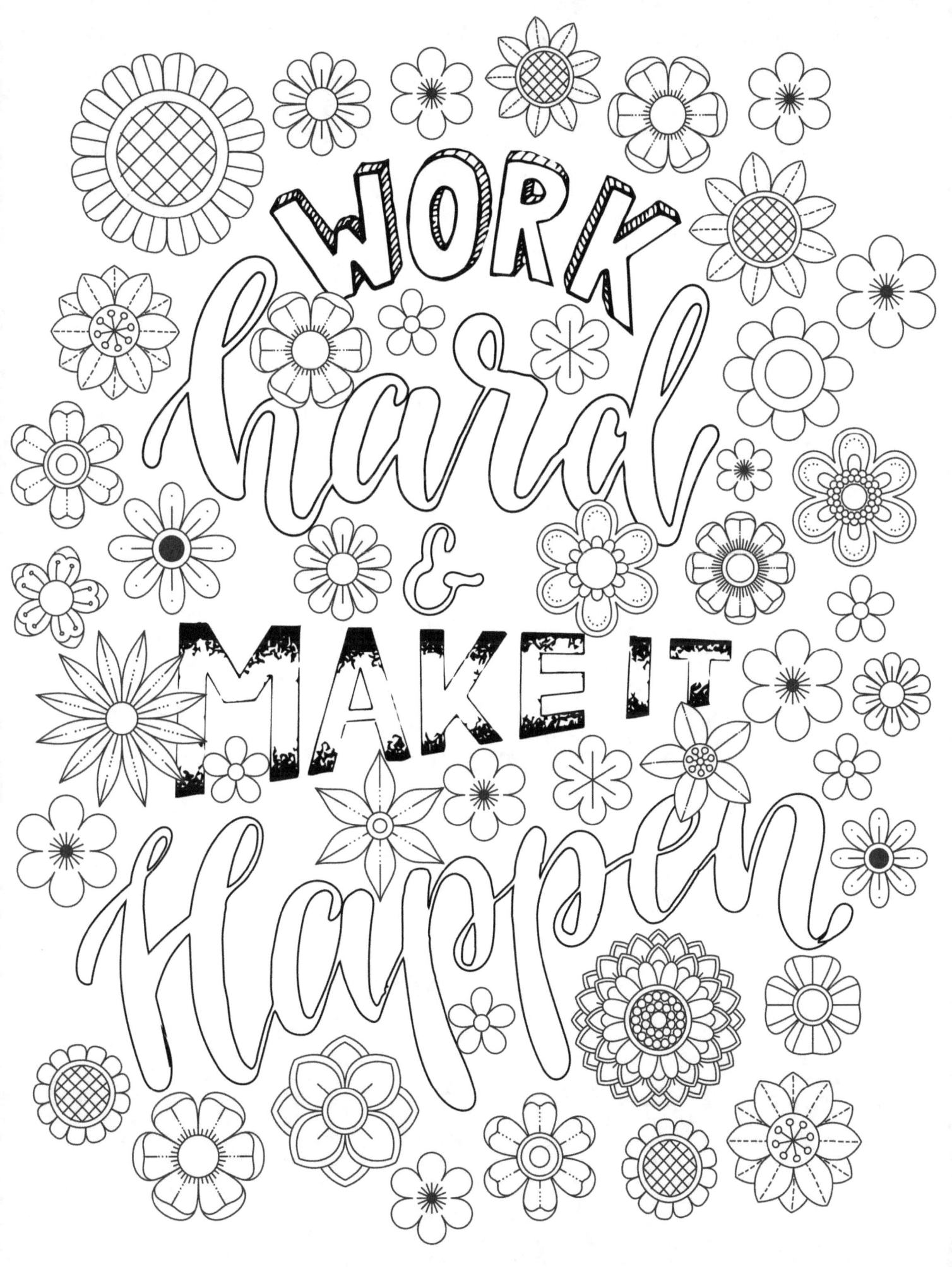

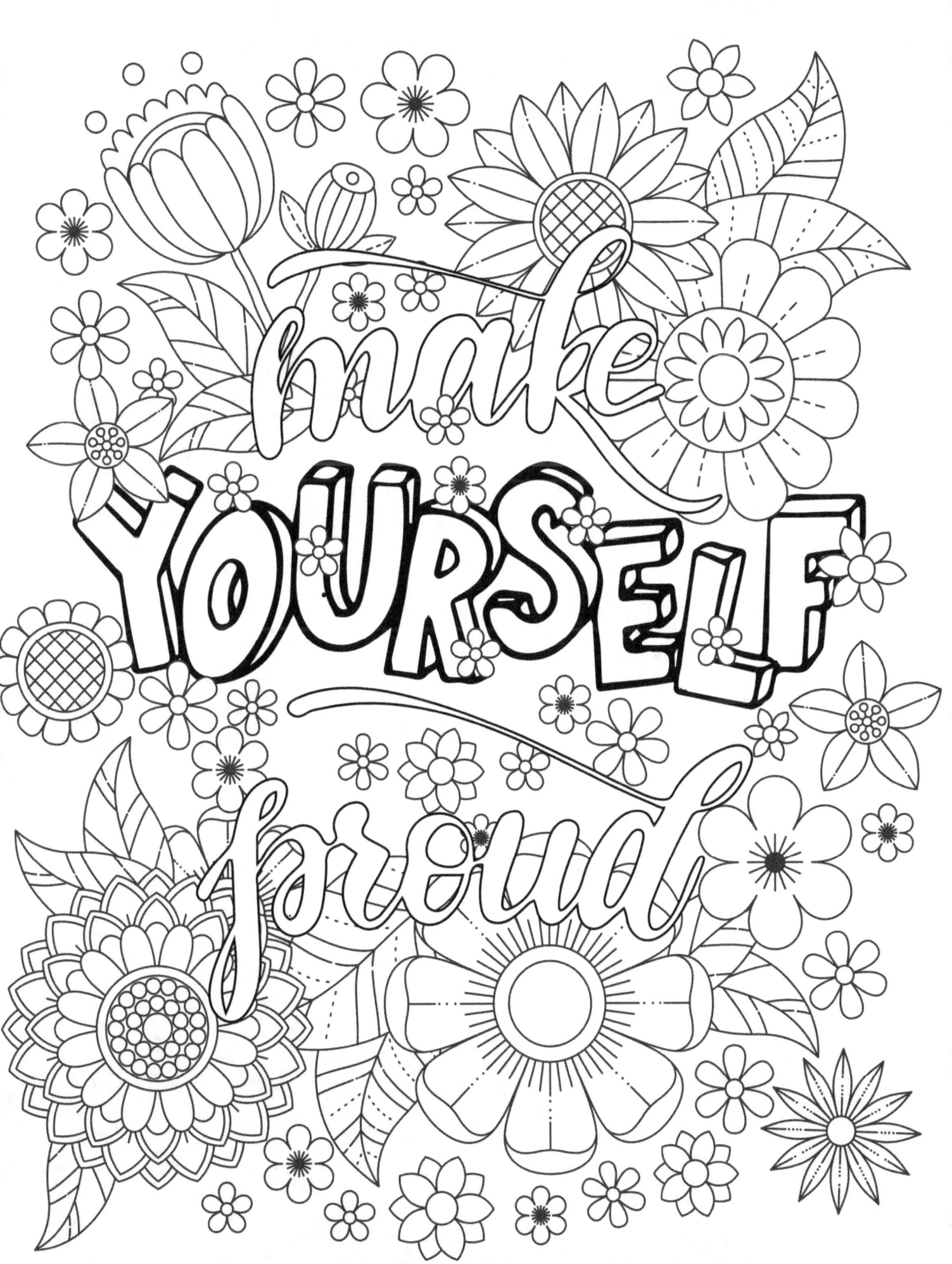

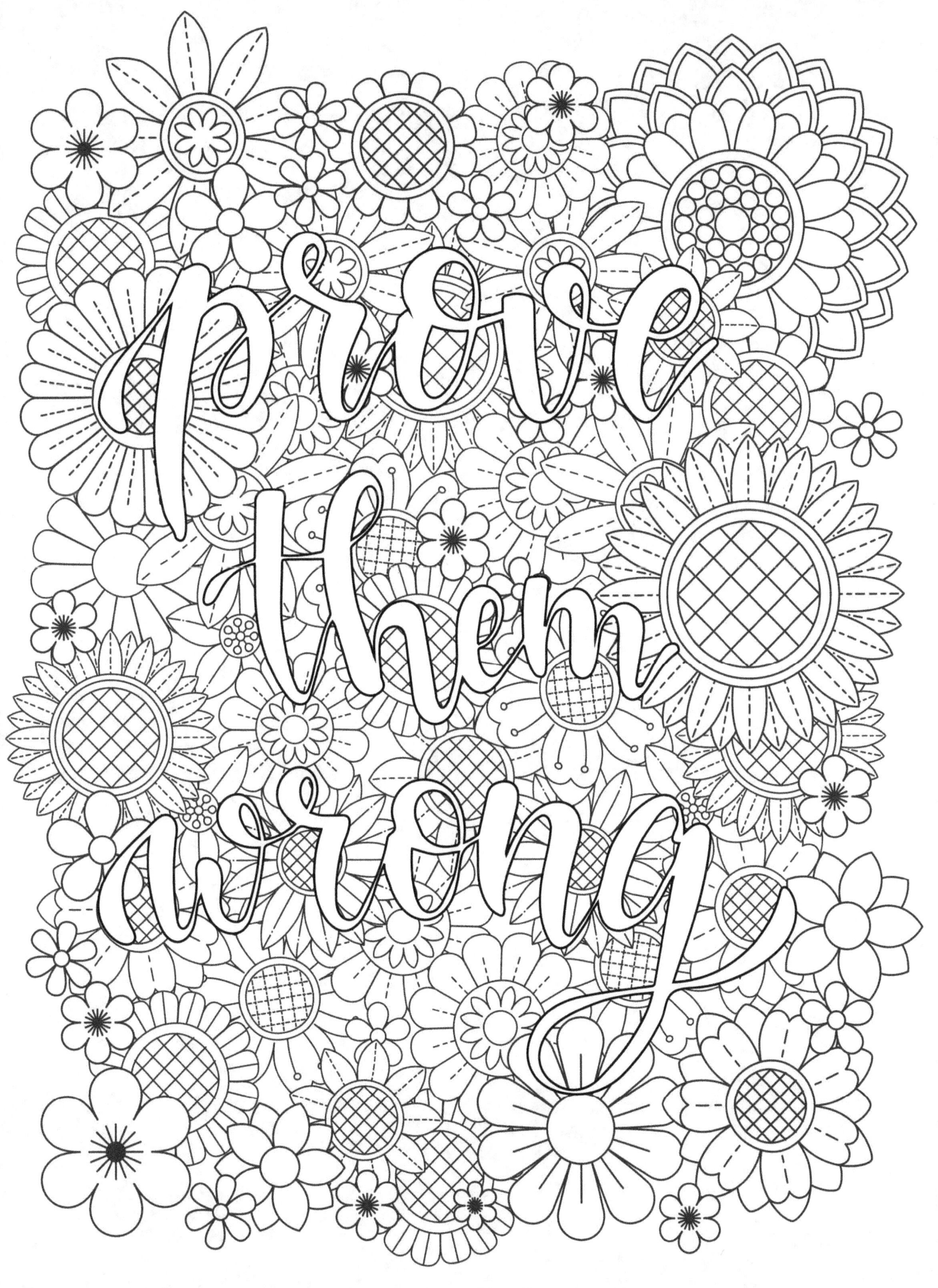

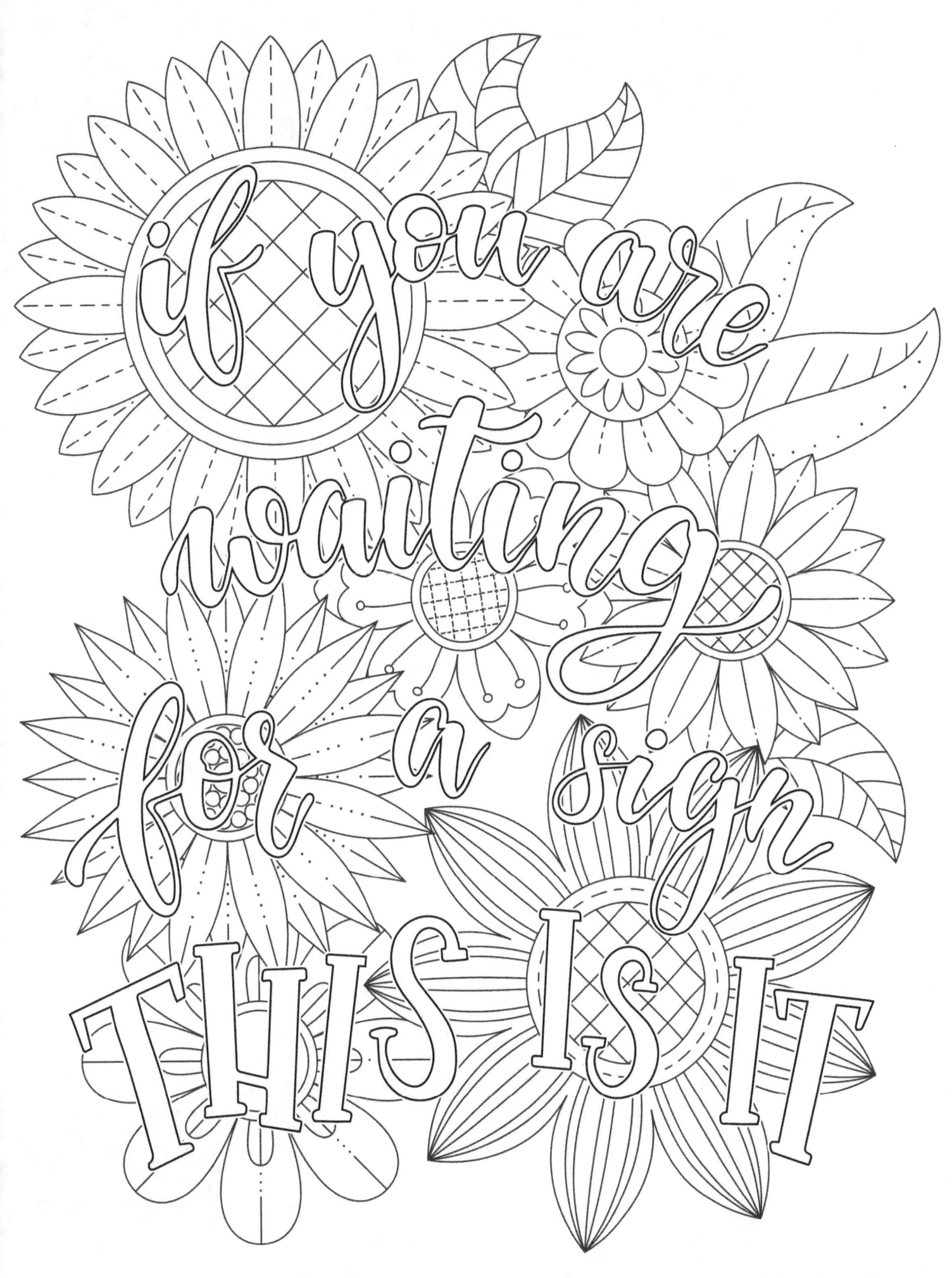

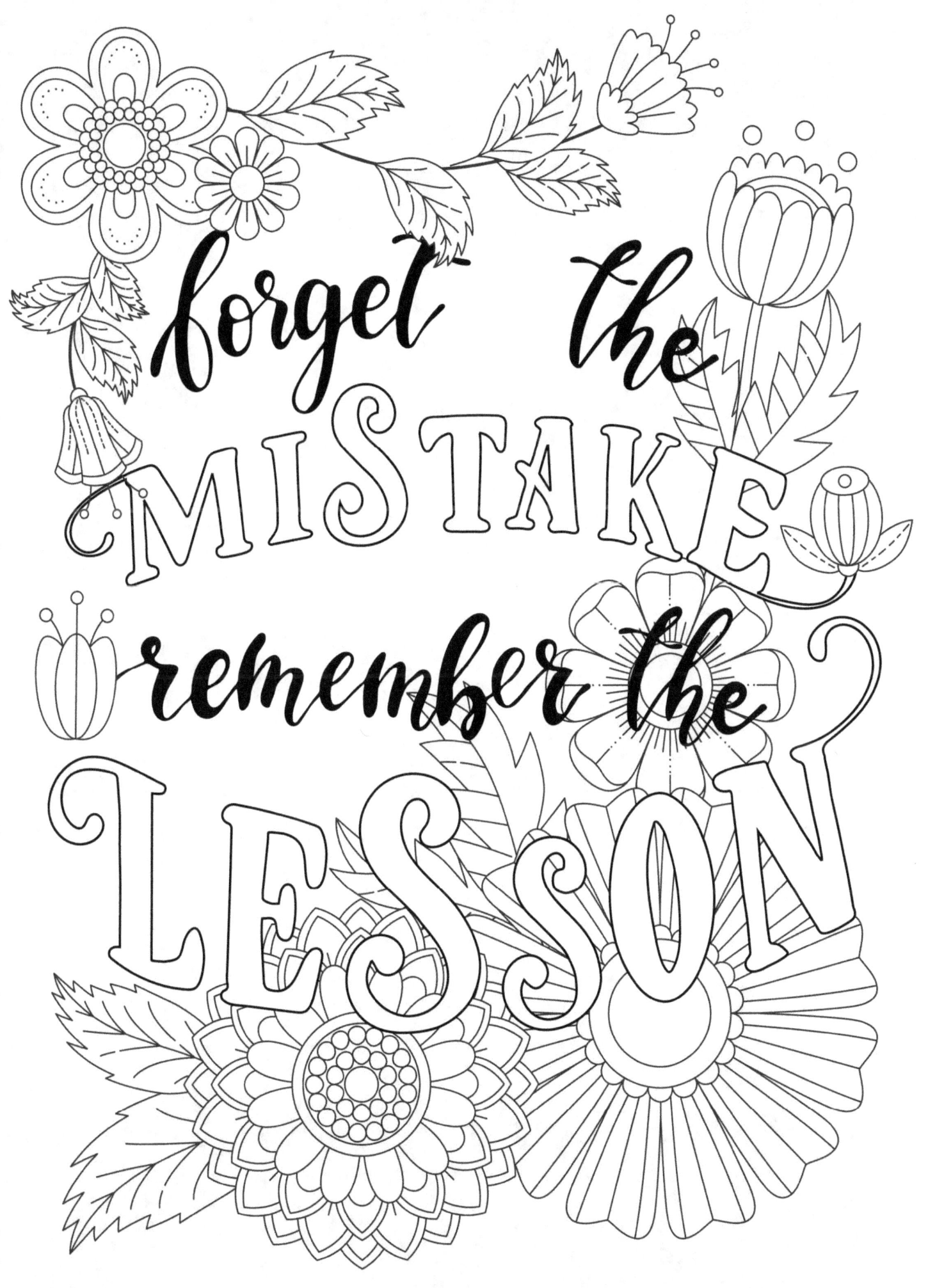

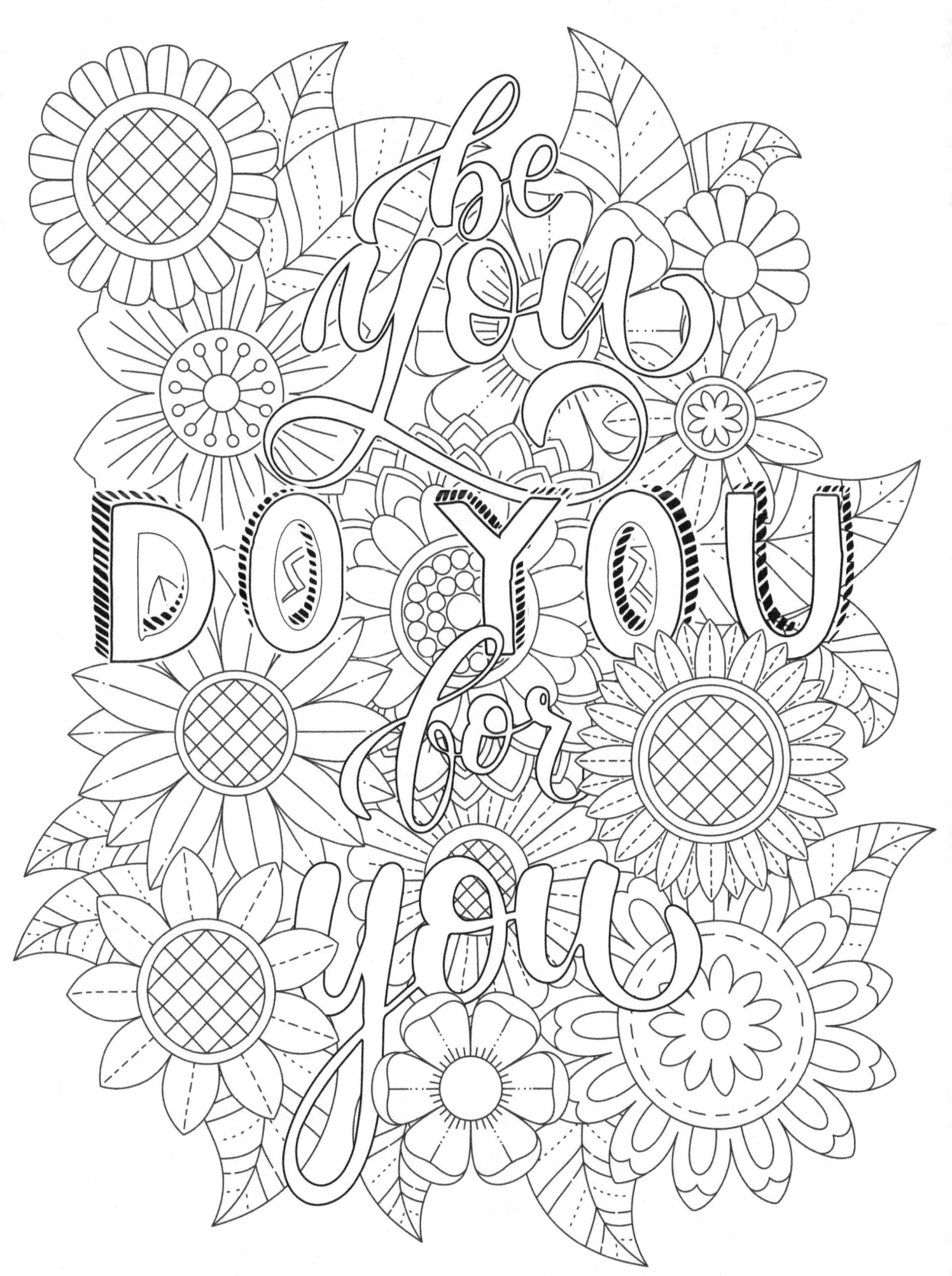

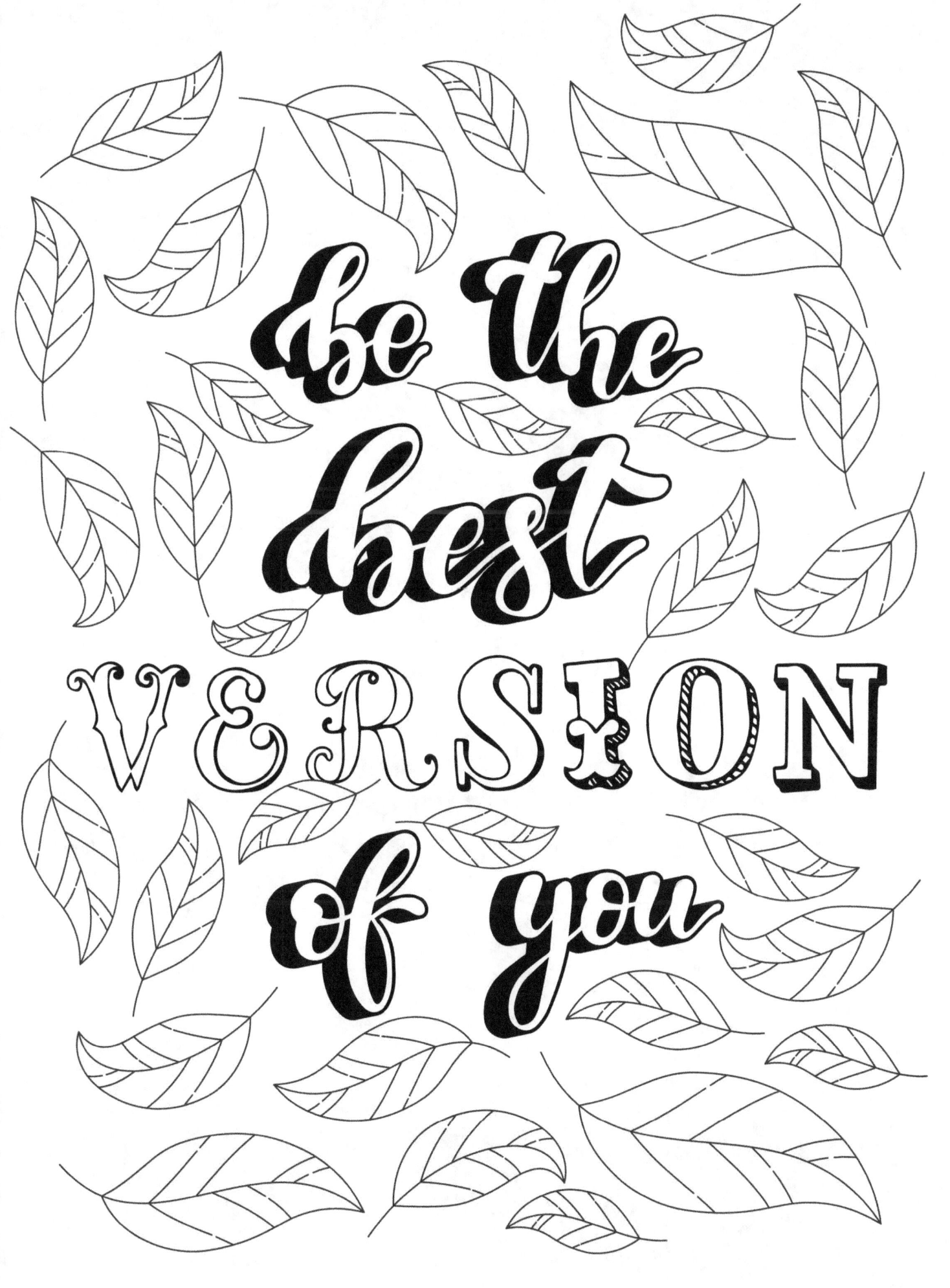

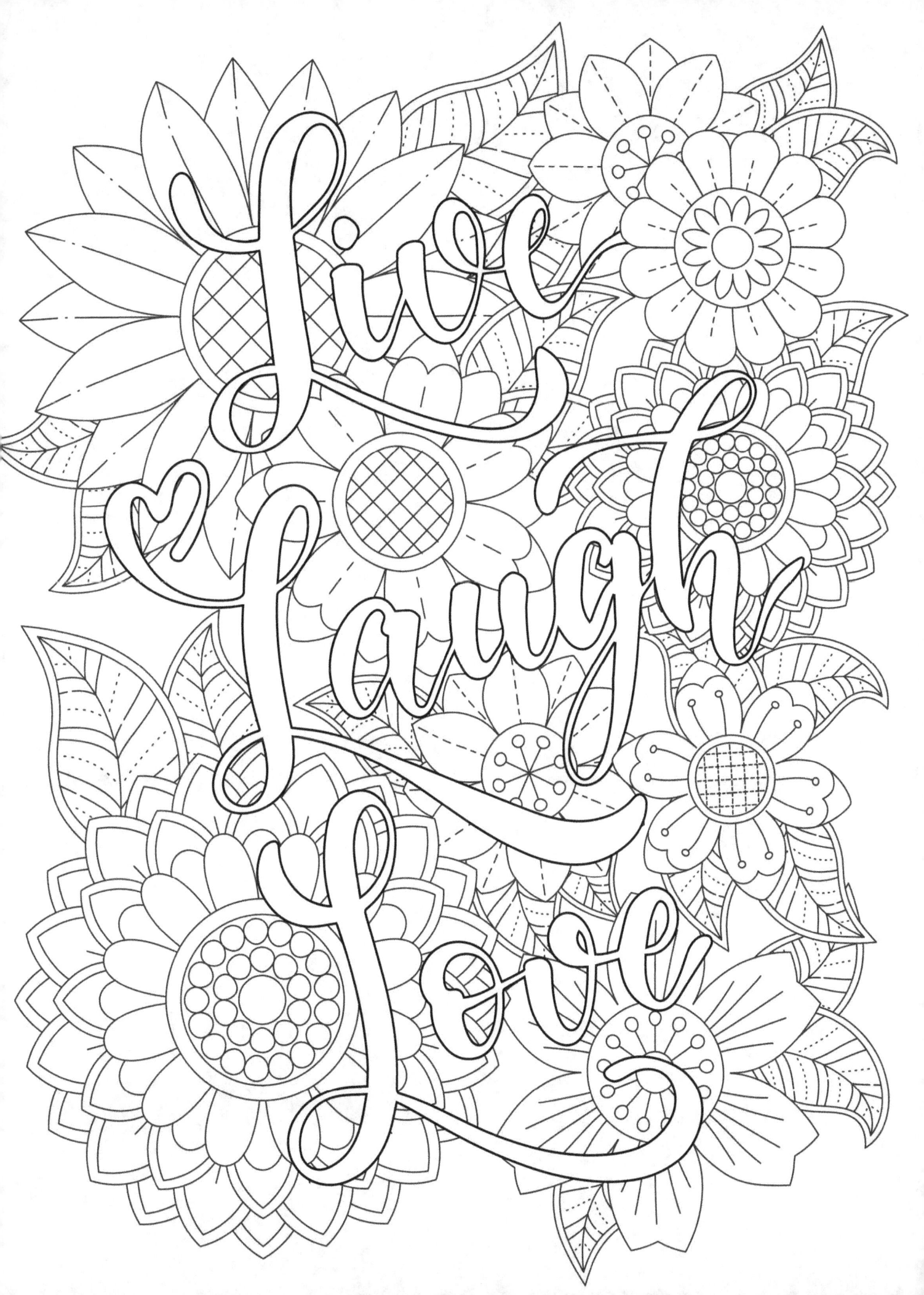

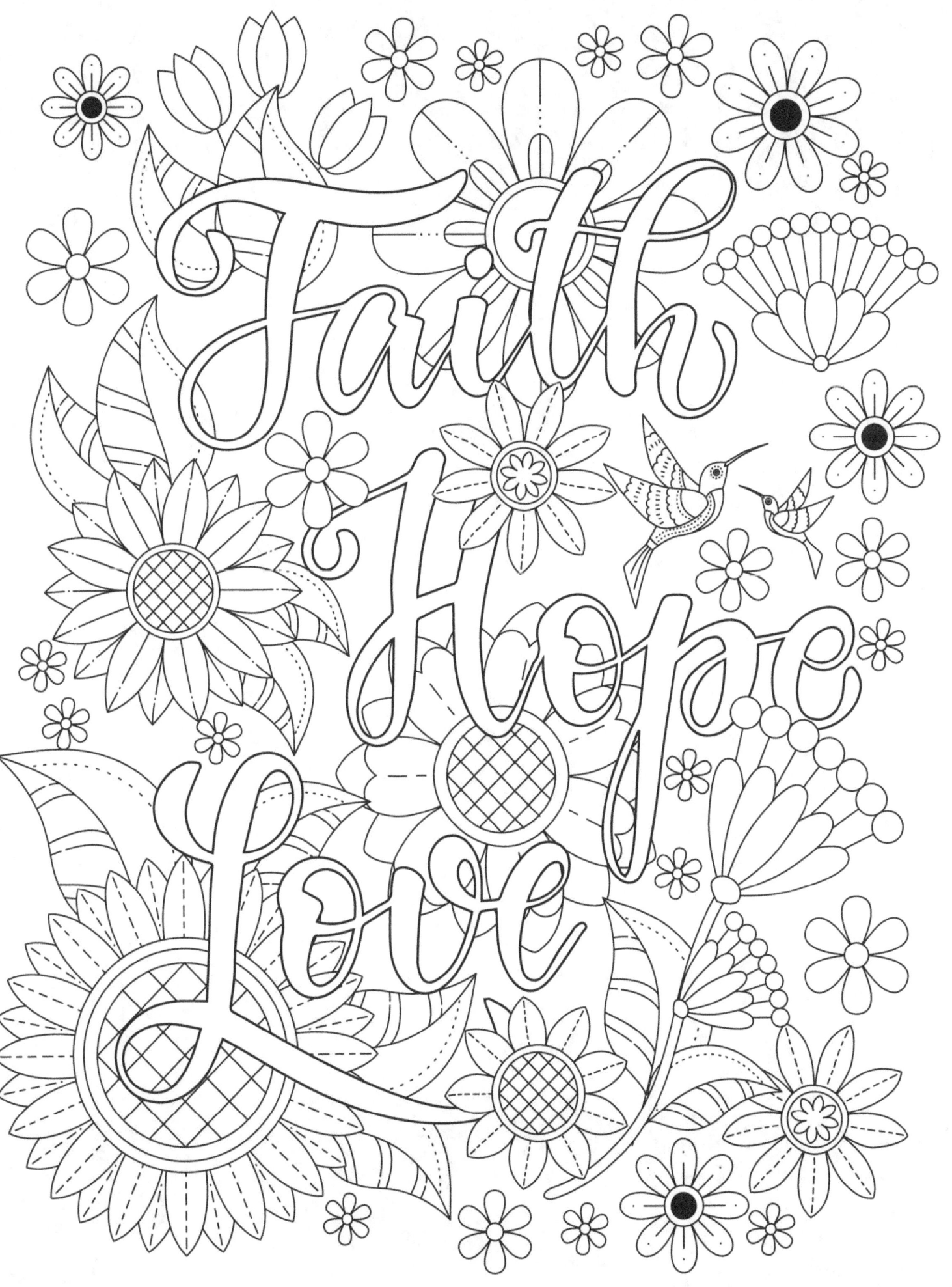

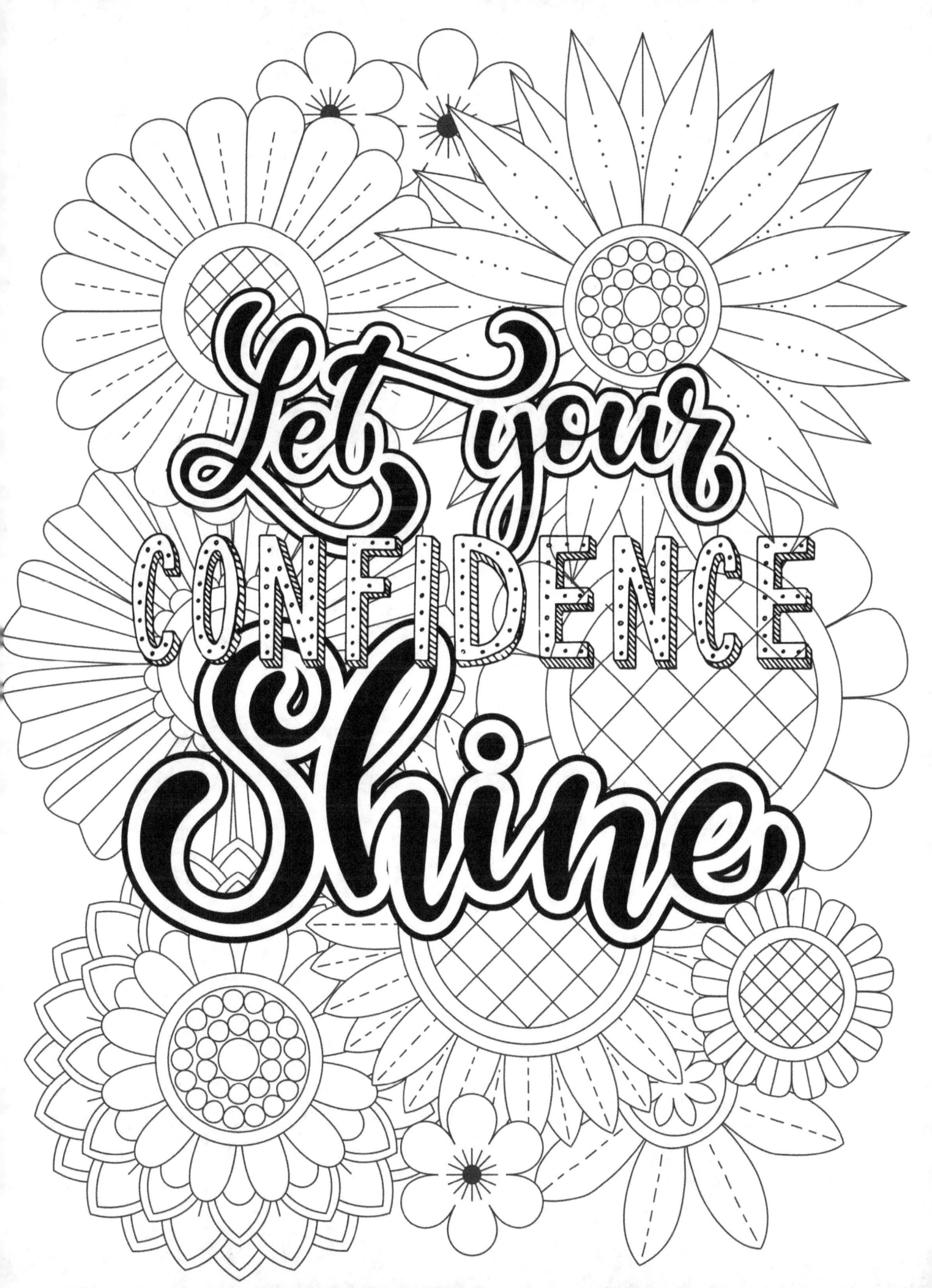

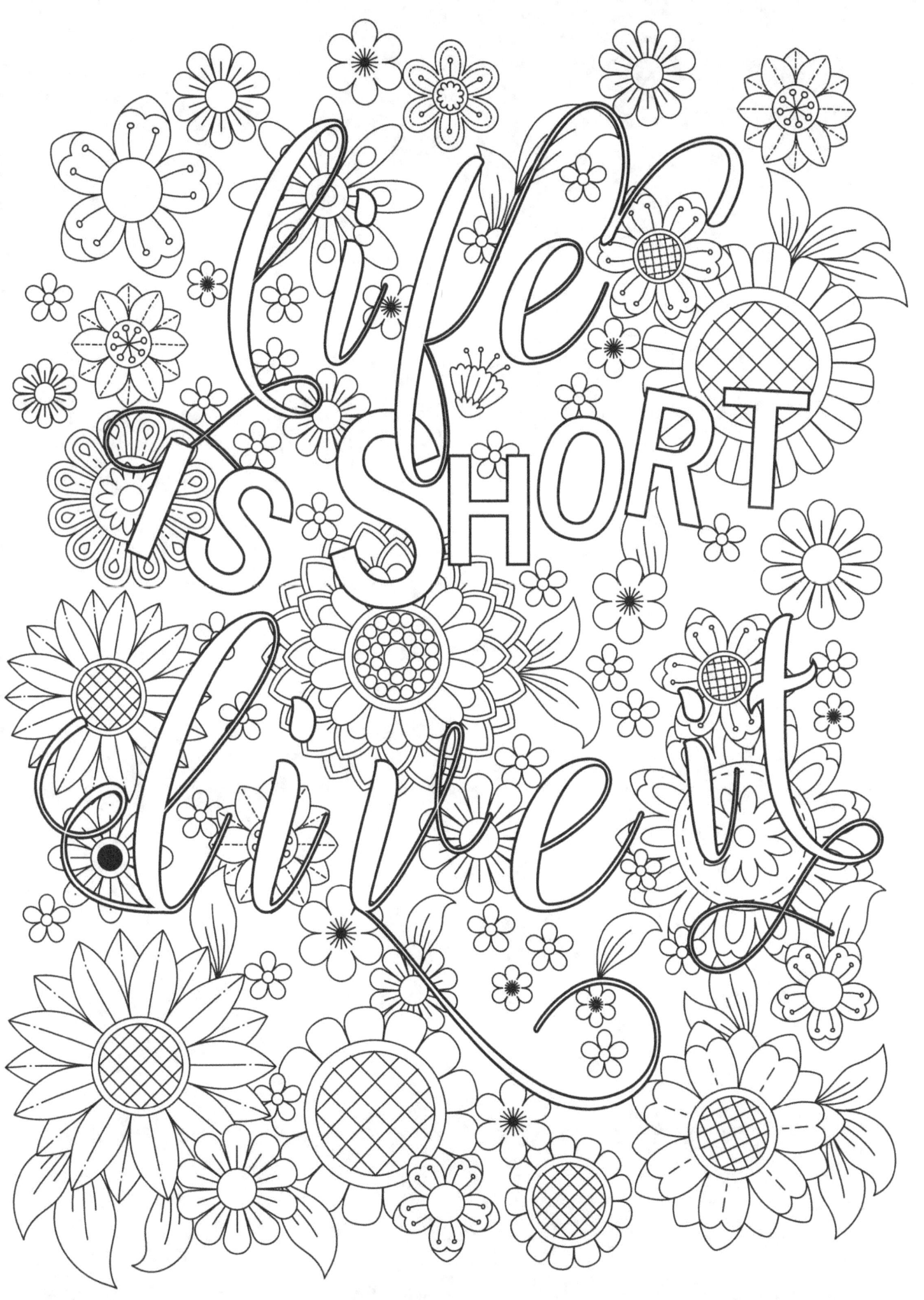

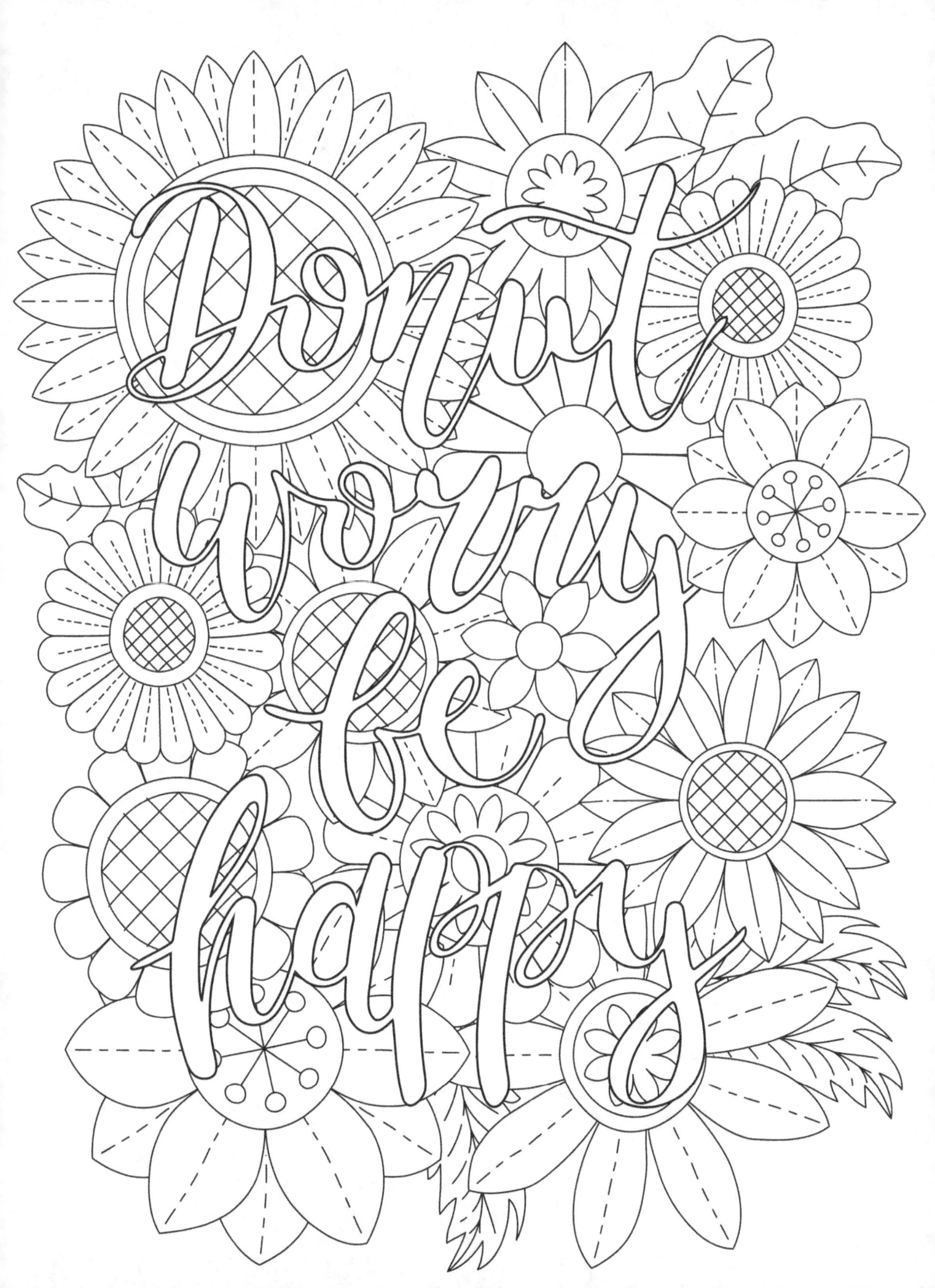

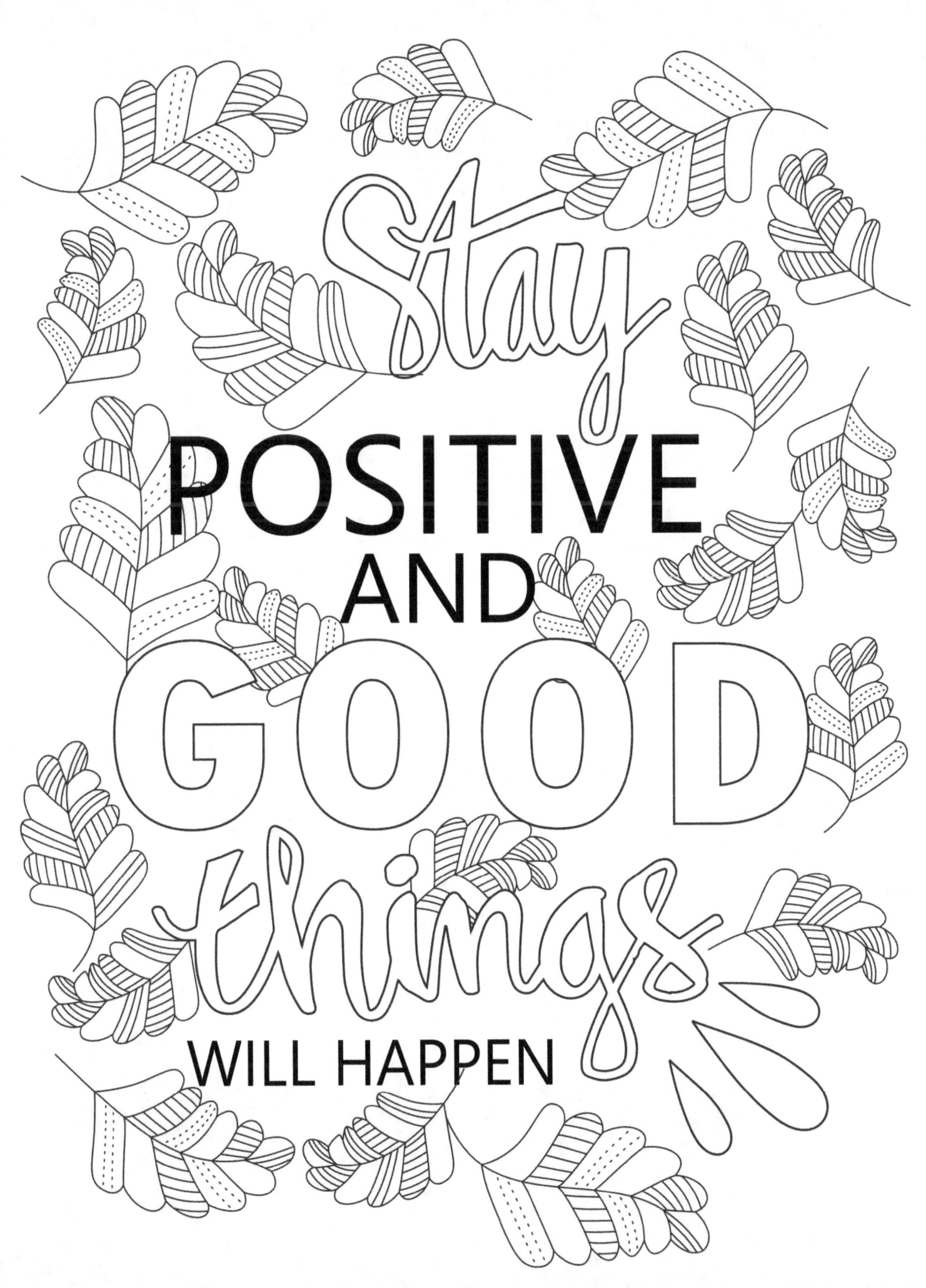

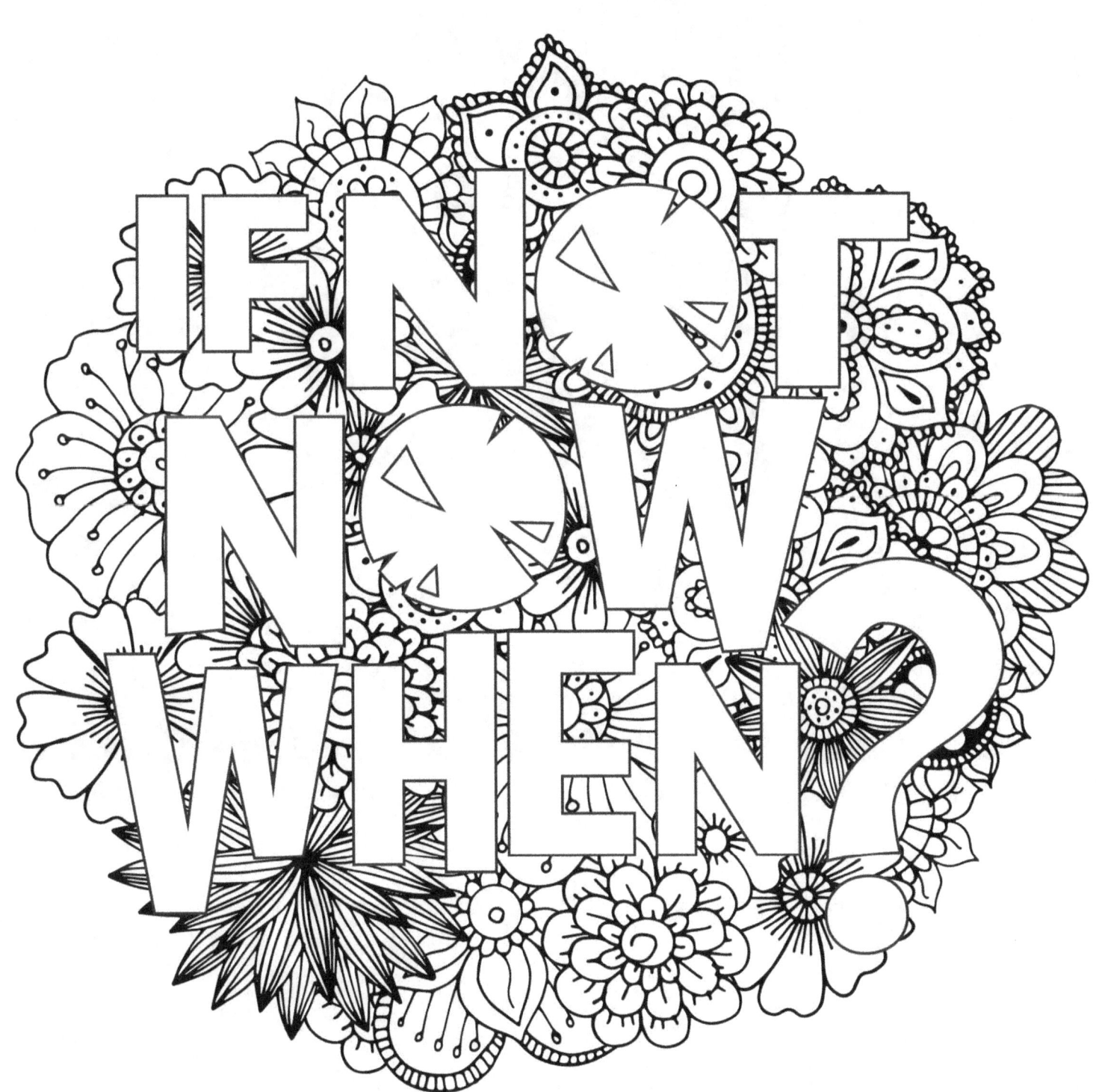

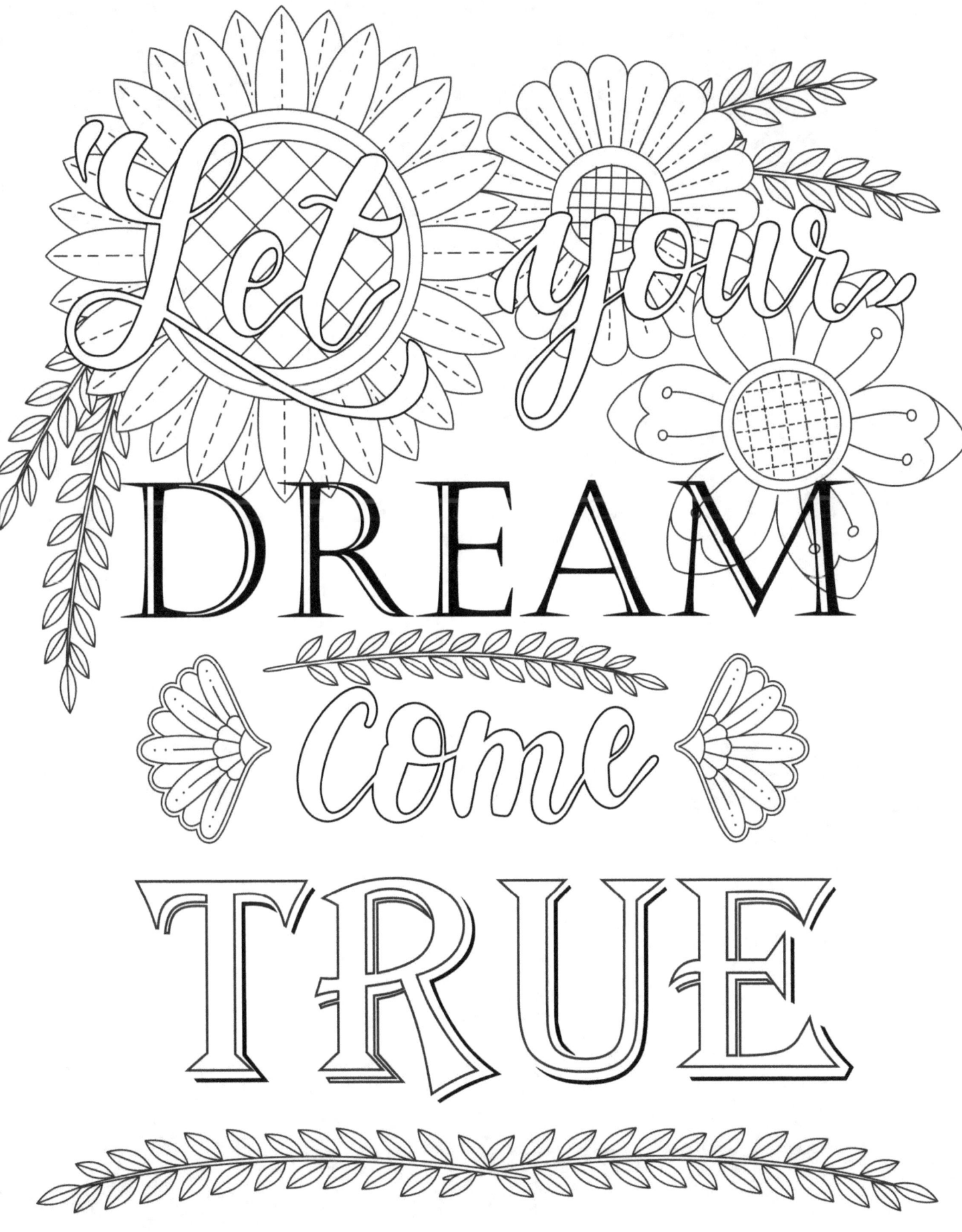

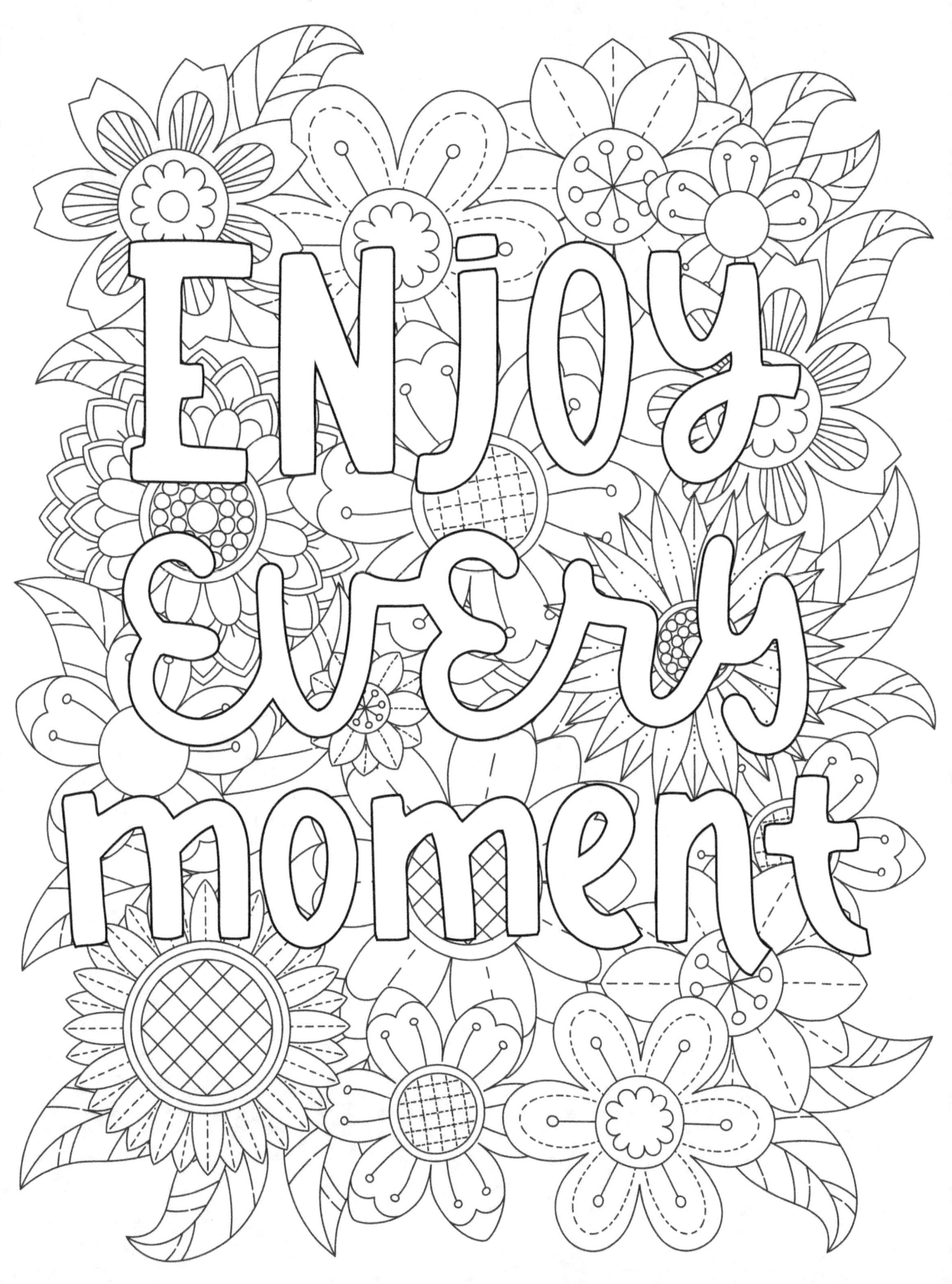

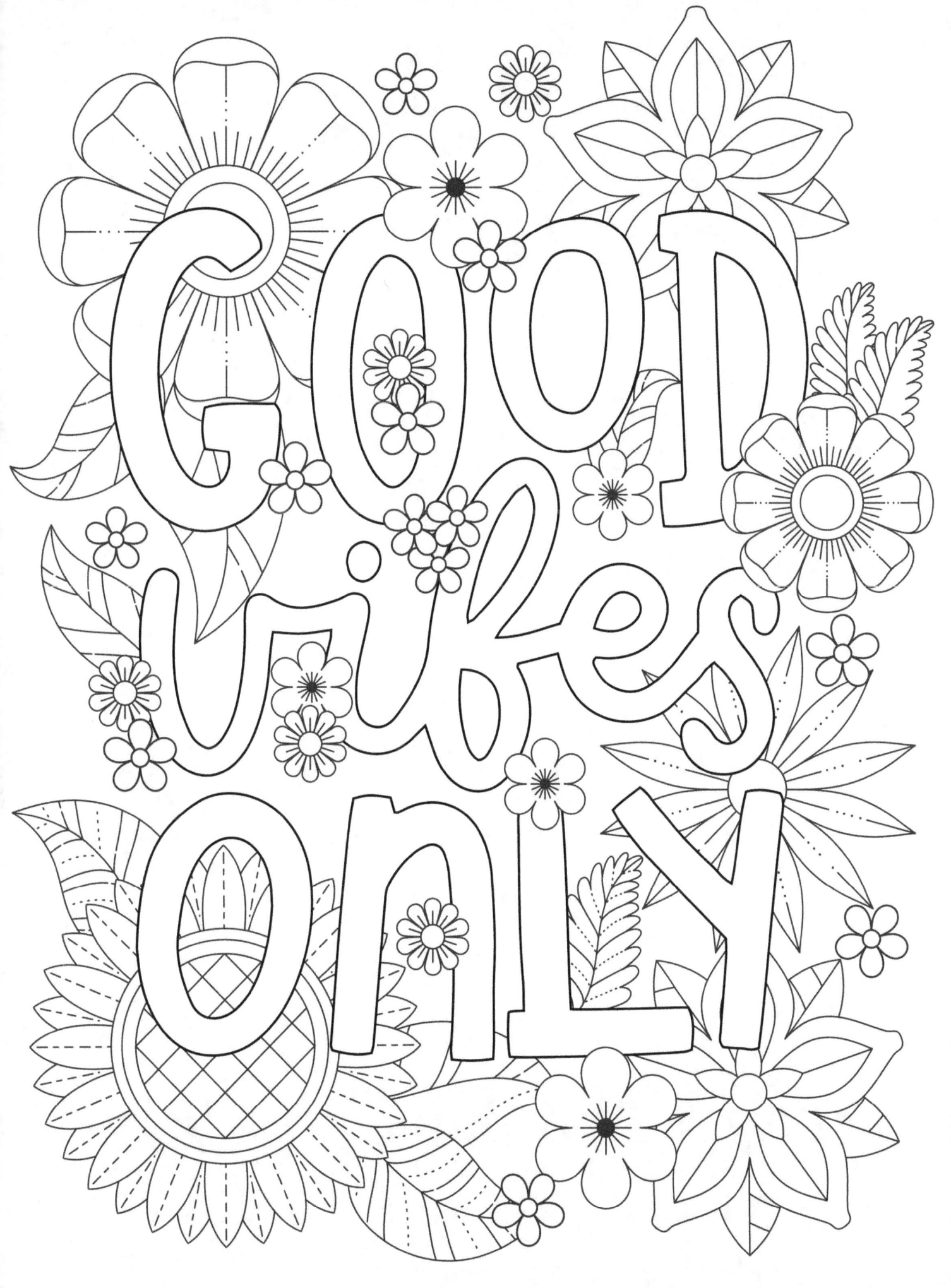

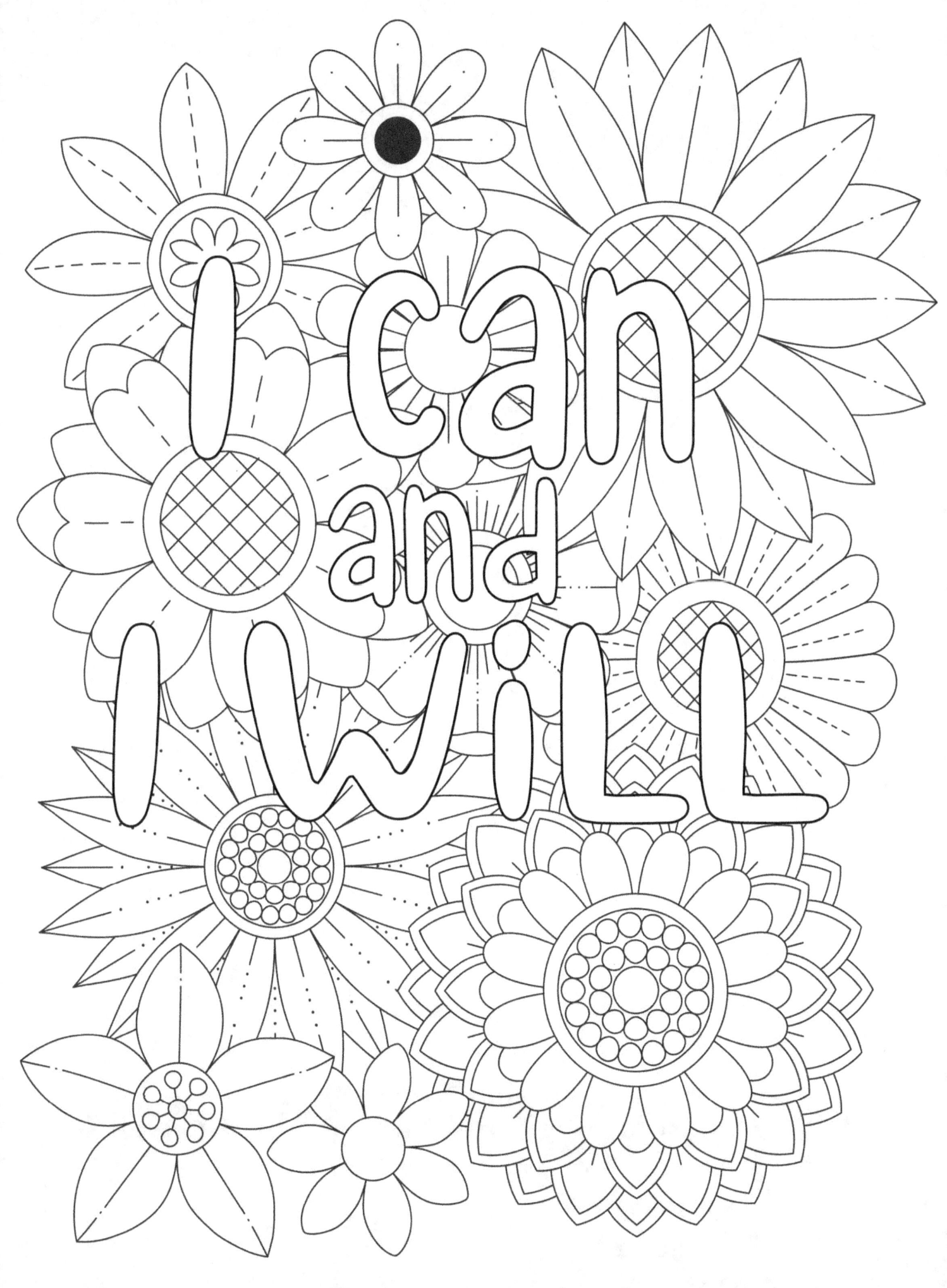

Test Color

Test Color

Test Color

www.ingramcontent.com/pod-product-compliance
Lightning Source LLC
Chambersburg PA
CBHW080619220526
45466CB00010B/3398